THE INDY 500
1956–1965

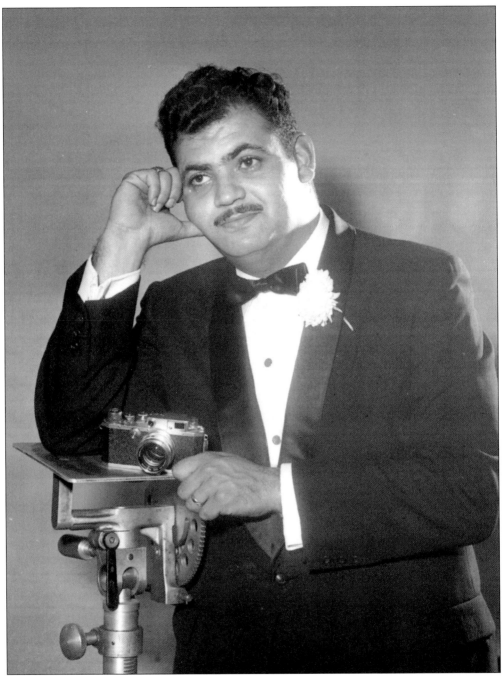

Photographer Ben Lawrence took photos of the Indianapolis 500 for the *Indianapolis Times* during the Golden Era of racing.

THE INDY 500
1956–1965

Ben Lawrence and W.C. Madden and Christopher Baas

ARCADIA
PUBLISHING

Published by Arcadia Publishing
Charleston SC, Chicago IL, Portsmouth NH, San Francisco CA

Printed in the United States of America

Library of Congress Catalog Card Number: 2004100698

For all general information contact Arcadia Publishing at:
Telephone 843-853-2070
Fax 843-853-0044
E-mail sales@arcadiapublishing.com
For customer service and orders:
Toll-Free 1-888-313-2665

Visit us on the Internet at www.arcadiapublishing.com

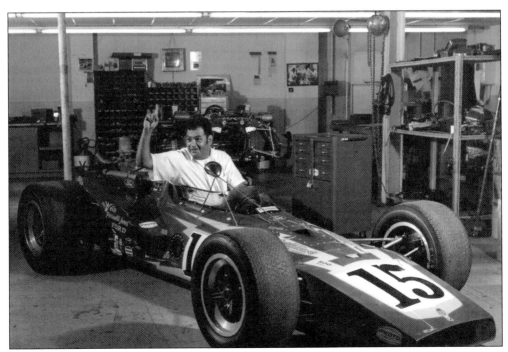

Photographer Ben Lawrence takes a seat in a Parnelli Jones' car.

CONTENTS

ACKNOWLEDGMENTS

This book is dedicated to the Indianapolis "500" Oldtimers' Club. A special thanks goes out to the following people for helping us with this book: Donald Davidson, Dick Mittman and Bob Clidinst helped identify many of the photos that went into this book; and Michael DeBurger helped with the making of the prints from the negatives.

These photos by Ben Lawrence are what's left from the archives of the Indianapolis Times, which went out of business in 1965. We hope you enjoy the look back in history.

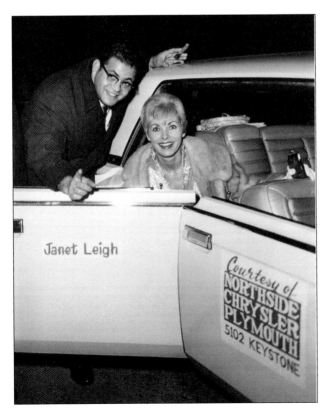

Janet Leigh

Ben Lawrence sometimes got on the other side of the camera as well. Here he is with Janet Leigh, a famous actress during the Golden Era.

INTRODUCTION

Ben Lawrence got into the newspaper photography business almost by accident. While he was a photographer for the daily newspaper at Shortridge High School in 1952, he came upon an accident scene. A reporter from the *Indianapolis Times* asked him to take photos of the scene for her newspaper. He lined up his 4x5 Speed Graphic and took what may have been his most important photograph of his life. The photo turned up the next day on the front page of the Times and his career was launched. After he graduated, he went to work for the Times.

Sports was one of the areas he was assigned to cover for the newspaper, and he began an annual journey to the Speedway for the Greatest Spectacle in Racing—the Indianapolis 500. His time at the track could be called the Golden Era (1956–1965), because 1961 was the Golden Anniversary of the race. The track actually opened in 1909, but the first Indy 500 was not held until 1911. Besides photographing all the pre-race festivities starting on Opening Day, he was responsible for photographing the start of each race from his position on the first turn high above the crowd from a photo stand on the roof of the grandstand. Then near the end of the race, he'd come down to Victory Lane to photograph the winner.

When the parade started in 1957, he was also assigned to cover it. He captured the transition of the race from the front-engined Indy cars with Offenhauser four-cylinder engines to the invasion of the rear-engine Lotus-Fords—some called them "funny" cars—and international drivers that ended the dominance and became the Golden Era of racing at the Speedway.

During the 1960s, Lawrence became the president of the Indiana News Photographers Association before The *Indianapolis Times* went out of business in 1965. He turned to working for a radio station for awhile before beginning his own photography business, which operated until 2003. During that time, he was also the chief photographer for the Washington Township Fire Department for 25 years. He's still a member of the Indianapolis "500" Oldtimers' Association and has a gold badge that allows him access to the track each year.

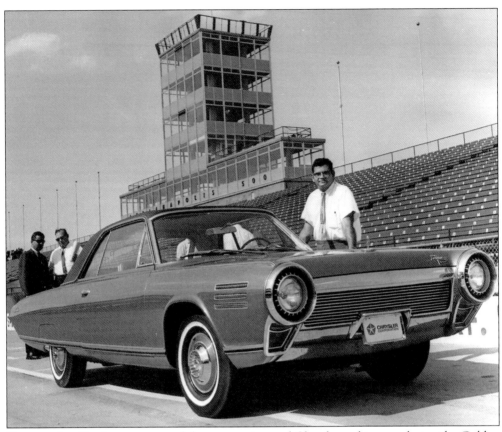

Photographer Ben Lawrence stands by an experimental Chrysler turbine car during the Golden Era at the Speedway.

ONE

Opening Day and Qualifications

During the Golden Era at the Speedway, the track would open on the first Saturday of May. Opening Day was always full of excitement and anticipation. The track was always packed with fans looking for their favorite drivers. Railbirds had their stopwatches out to see how fast the cars were turning laps.

Qualifications were held over two weekends prior to the race. Most of the field was filled during the first weekend, which usually resulted in a suspense filled last weekend of qualifications. The last day of qualifications was known as Bump Day. After the field of 33 was filled, anyone who had a faster time than someone in the field would bump the last qualifying car from the field. That team could come back to try and do the same thing unless time ran out, which was 6 p.m. For example, rain was the problem in 1956. The second weekend of qualifications was washed out except for 57 minutes. However, the field was still filled with 33 cars. One of the drivers washed out of the race was Italy's Guiseppe "Nino" Farina. In 1962, Norm Hall crashed into the southwest wall and received severe head injuries while qualifying.

The black-and-white checkered theme at the track is evident in ribbon cutting ceremony on Opening Day in 1962 at the start/finish line. The home stretch was paved with asphalt, except for the strip of bricks before the 1962 race.

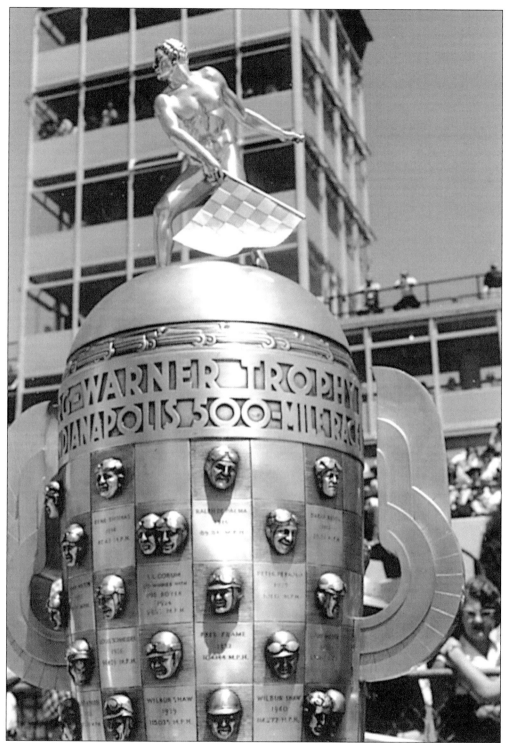

Winners of the Indianapolis 500 get recognized on the Borg Warner trophy, which was first presented in 1936. The control tower in the background replaced the pagoda in 1957 and lasted until 2000.

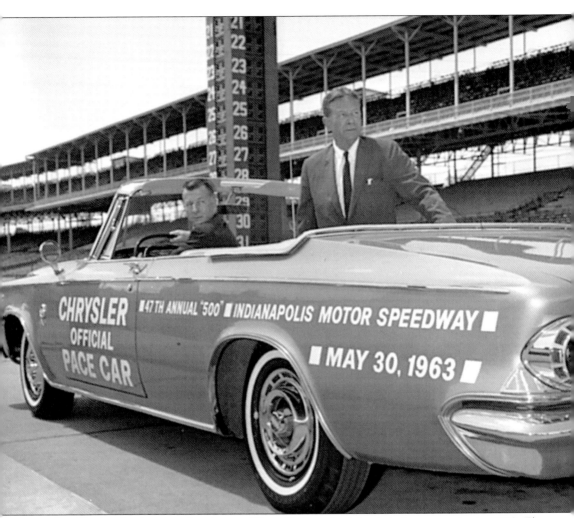

Sam Hanks, the director of racing, and Tony Hulman look back during a practice in 1963. The Chrysler convertible was the official pace car that year.

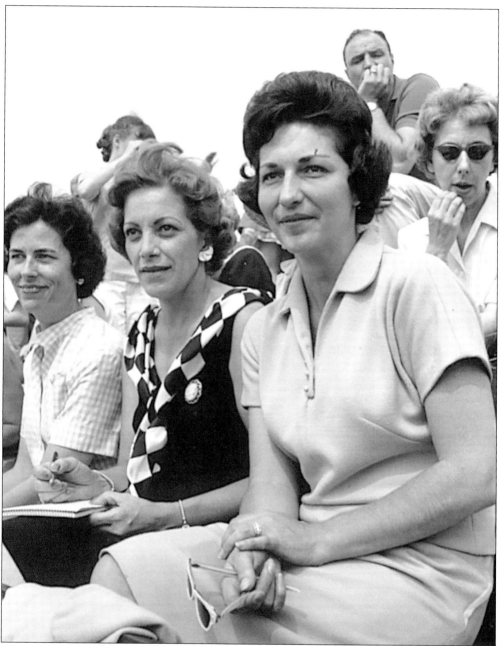

Drivers' wives watch their husbands from the Tower Terrace bleachers on Opening Day in 1962.

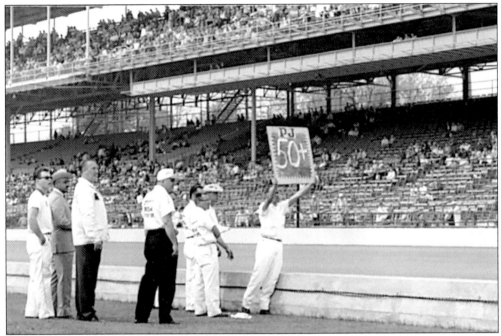

A crewmember holds up a 50+ sign to signal Parnelli Jones that he is blistering the track at more than 150 mph. Jones broke the 150 mph barrier in 1962 during qualifications. The man with the cowboy hat is his owner J.C. Agajanian.

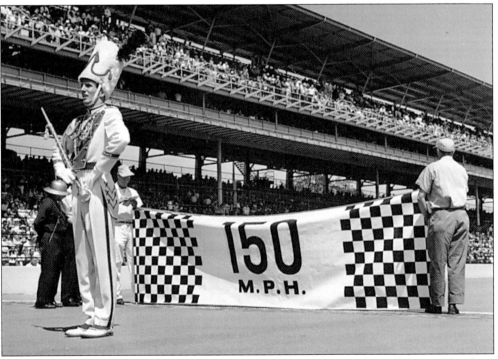

Track officials hold up a 150 mph banner before a ceremony honoring Parnelli Jones. The drum major for Ben Davis High School got in this photo as well.

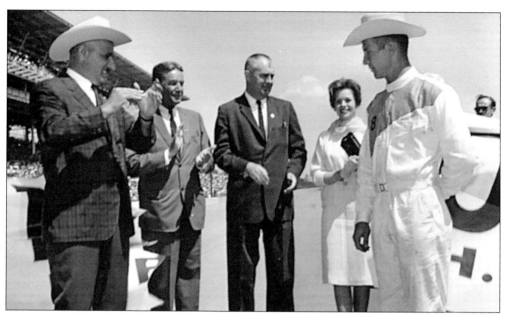

In 1963, J.C. Agajanian applauds the efforts of his driver, Parnelli Jones, after he broke the 150 mph barrier in 1962. Also applauding the effort was Tony Hulman, Bob Moorhead and Queen Mary Lou Mugg.

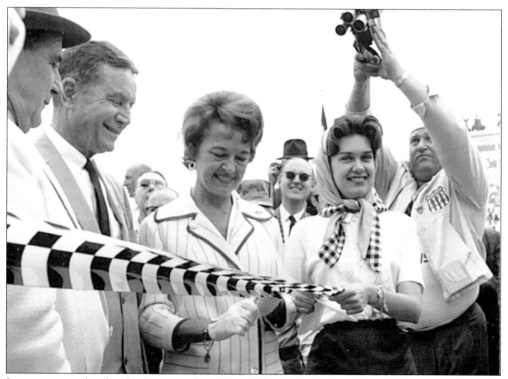

It was a great day for the Joneses when Parnelli Jones broke the 150 mph barrier on May 12, 1962. Jerilyn Jones, the 500 Festival Queen, was on hand when Mrs. Frank McKinney, festival chairman, cut the ribbon with Speedway owner Tony Hulman.

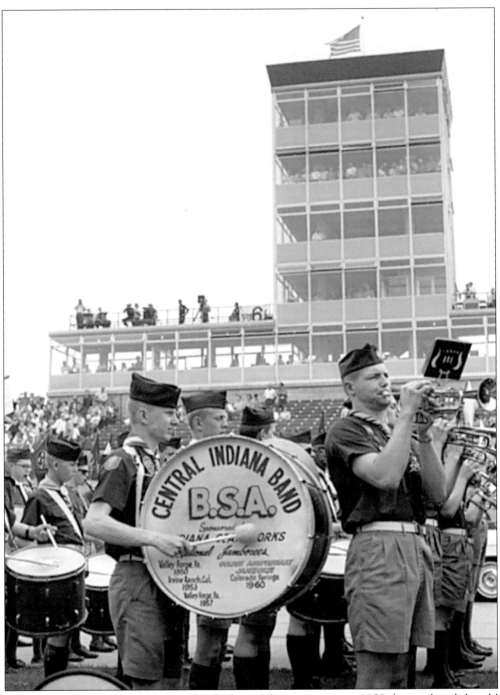

The Central Indiana Band plays in the shadow of the new tower in 1958 that replaced the old pagoda, which was razed in 1957.

The Ben Davis High School band performed at the track before the first day of qualifications in 1963. It was a beautiful spring day in Speedway.

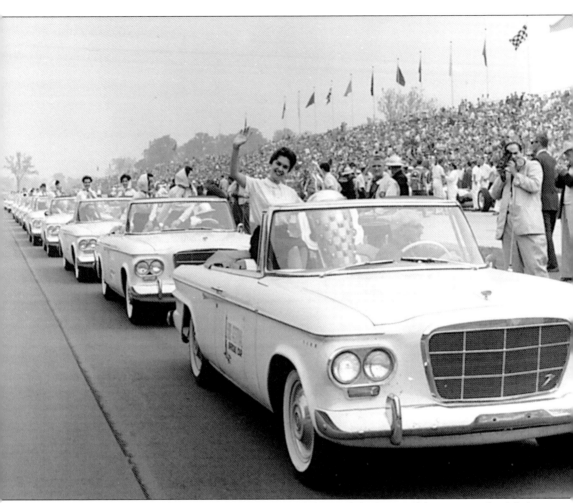

Queen Jerilyn Jones and her court parade around the track before qualifications in Studebaker Lark convertibles in 1962.

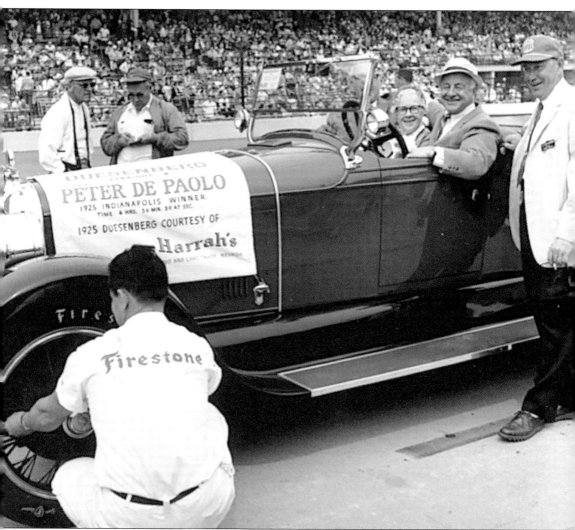

At the Opening Day Ceremonies in 1962, Peter De Paolo drove around the track in a 1925 Duesenberg, a passenger car version of the one he drove to victory in 1925. The straight-eight Duesenberg circled the Brickyard in 4 hours, 56 minutes and 39.47 seconds in 1925. This particular Duesenberg was sponsored by Harrah's Casino of Reno and Lake Tahoe, Nevada. He started seven races between 1922 and 1930.

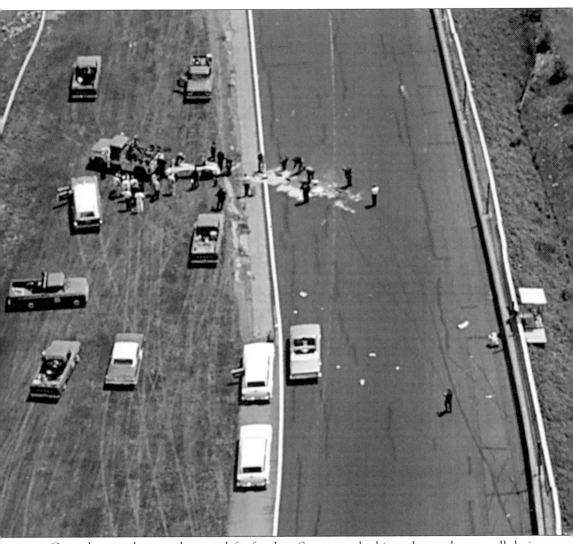

Ground crews clean up the mess left after Len Sutton crashed into the southwest wall during practice on May 21, 1963. Ben Lawrence took this photo from an Air Florida helicopter.

Chief Mechanic Gene Marcenac and the Novi team held his head down during qualifications, but he had nothing to be ashamed of as his driver, Bill Cheesbourg (below), qualified in 33rd position for the 1958 race. Driving a roadster, Cheesbourg finished 10th in the race, which was the best finish in his six races at the Speedway.

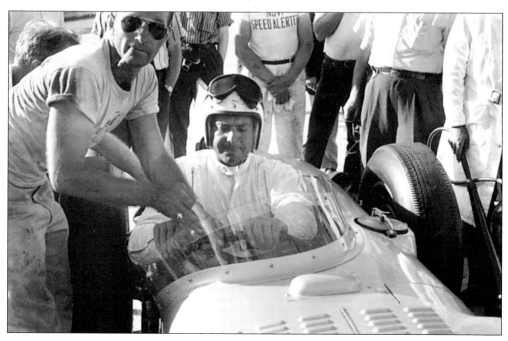

Crews cleanup after a car skidded on the first turn into the short chute. The incident occurred

during practice in 1965. A.J. Foyt and Parnelli Jones had trouble during practice as well that year.

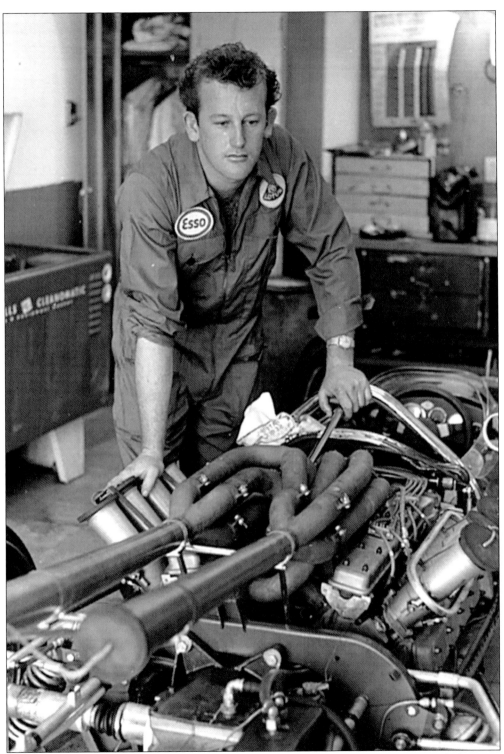

Mechanic Dave Lazemby works on the Lotus model 38. He was member of Jim Clark's rear-engined Lotus-Ford team.

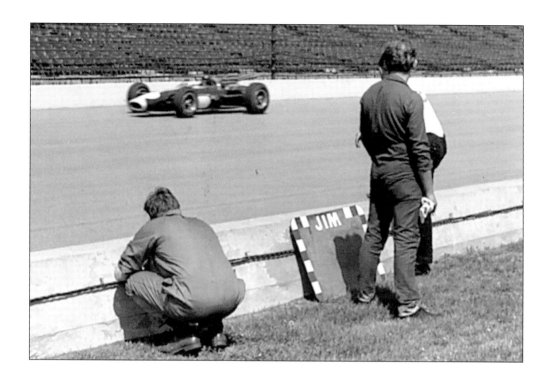

Jim Clark tests a rear-engined Lotus model 34 in 1964. He finished in second that year and won the following year.

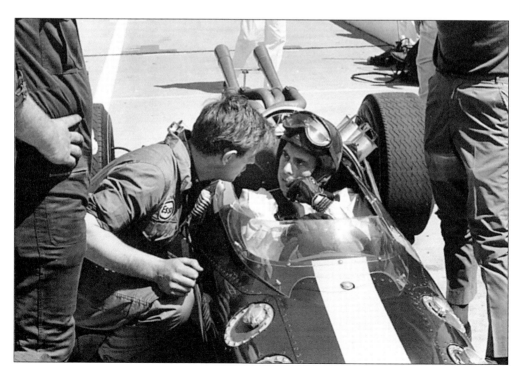

When not trying to qualify, some drivers spend time clocking other drivers as in this photo of A.J. Foyt checking the times of competitors in 1965.

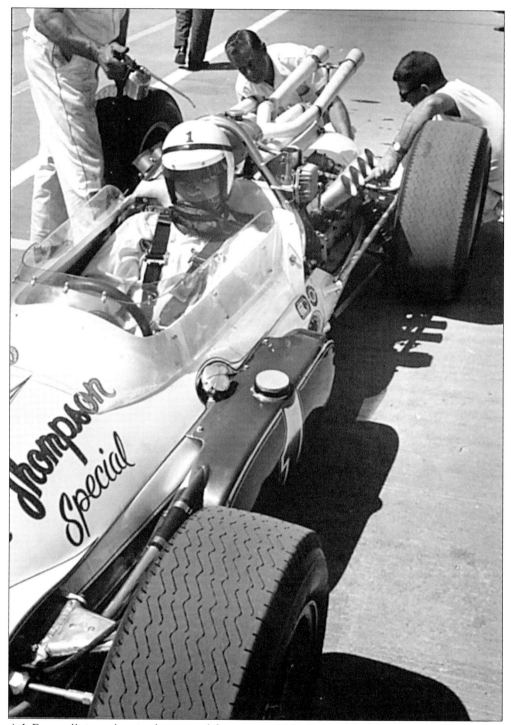

A.J. Foyt pulls into the pits during qualifications in 1965. He qualified the Sheraton-Thompson rebuilt Lotus 34 on the pole, but the reigning champion was knocked out of the race on lap 115 with gearbox problems. He finished 15th.

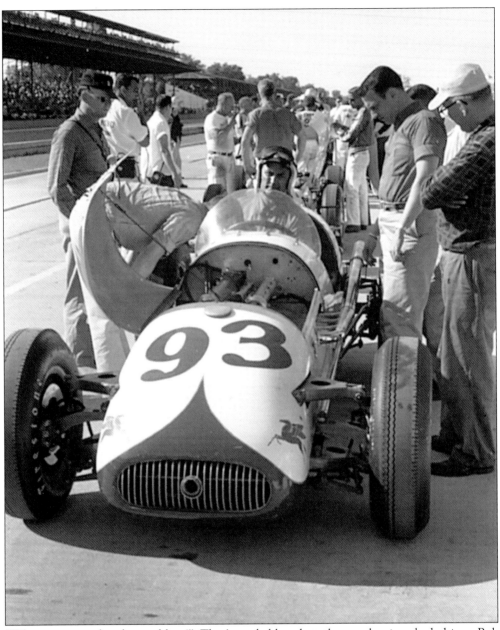

"What seems to be the problem?" That's probably what the mechanic asked driver Bob Courtner, who tried to qualify this Kurtis 3000 series car in 1958. He failed to qualify and never got to race in the 500 before he died in a crash.

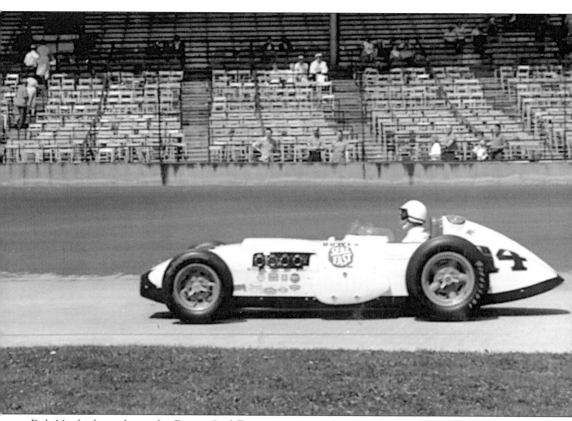

Bob Vieth slows down the Bowes Seal Fast car to enter the pits after qualifying fourth for the 1958 race. Veith was knocked out in the first lap after he hit Jimmy Reece in a 15-car crash.

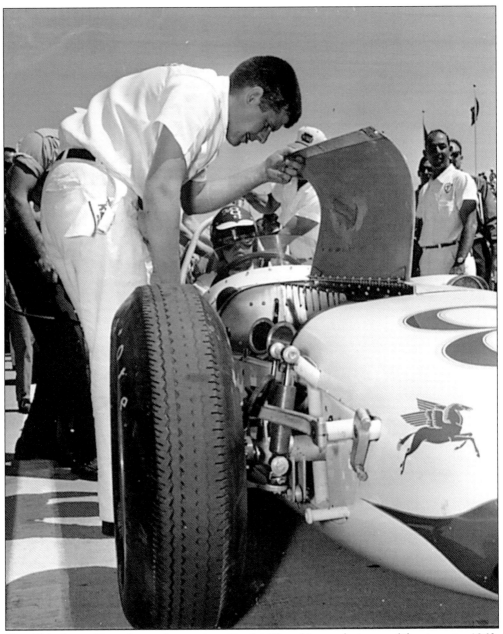

Chief Mechanic Dave Laycock examines Jim McElreath's car during qualifications in 1963. McElreath qualified and finished sixth that year. In all, he started 15 "500" races and his best finish was third in 1966.

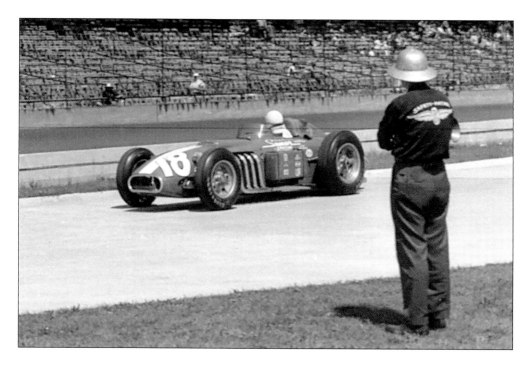

Time ran out on Marshal Teague when he tried to qualify the Sumar Special for the 1958 race. "This is the third time I've died here within two slots of being next in line to qualify when time ran out," he told the *Indianapolis Times*. Teague did drive in the 500 in 1953 and 1957. He was killed in 1959 in a crash at Daytona.

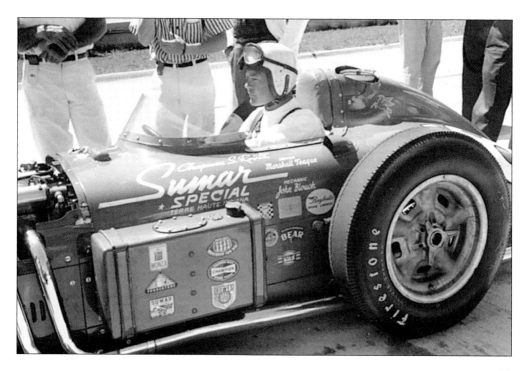

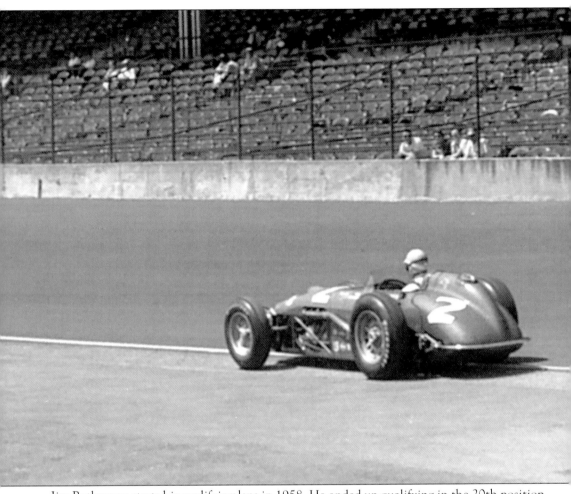

Jim Rathmann starts his qualifying laps in 1958. He ended up qualifying in the 20th position and finished the race in fifth place. He raced in 14 "500s" between 1949 and 1963. He won the race in 1960.

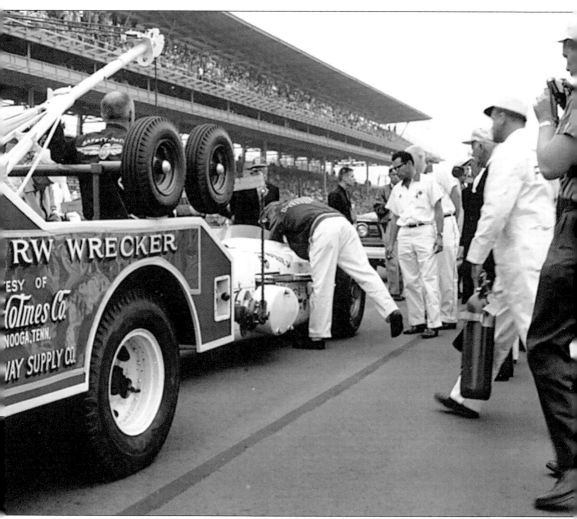

The wrecker had to be called in to retrieve Eddie Sach's Dean Autolite Special in 1962 during qualifications. Sachs qualified 27th and finished third that year.

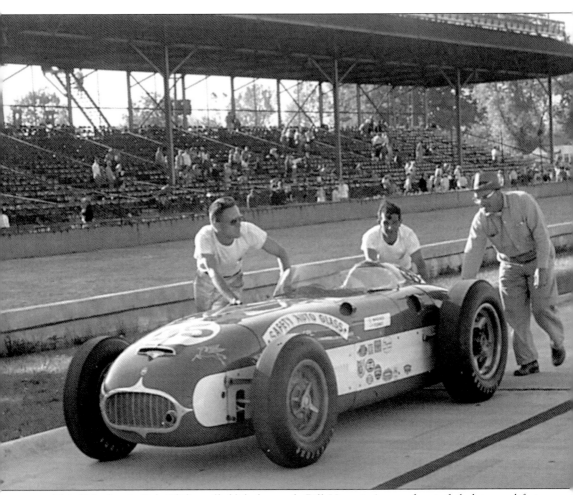

Chief Mechanic Bob Clidinst (left) helps push Bill Homeier's car after it failed to qualify in 1958. In a show of sportsmanship, Clidinst flashed a sign to Homier to come in after the car failed to get up enough speed to qualify, so that another car could qualify before time ran out on qualifications. Homier qualified and raced in the 1954 and 1960 "500."

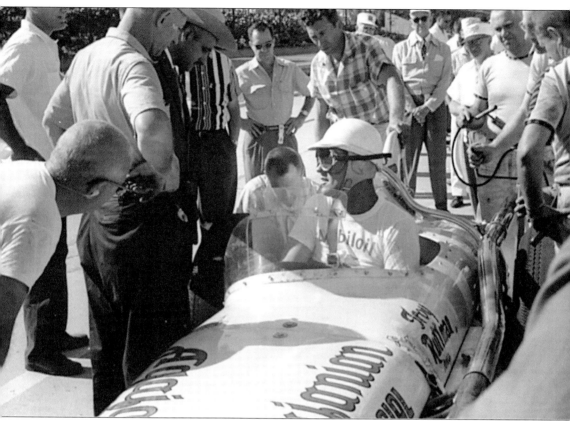

J.C. Agajanian told his driver, Troy Ruttman, "Okay, Troy, we'll be back next year." This came on the final day of qualifications on May 26, 1958, when Ruttman tried to qualify the Agajanian Special, but the car wouldn't perform right, so he pulled in after a couple of laps to give other racers a shot. For the second consecutive year, Lady Luck turned its back on Agajanian.

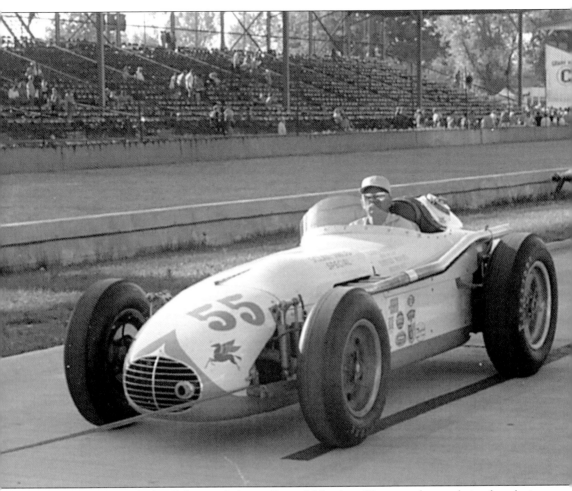

Eddie Russo took the Sclavi and Amos Special Number 55 on to the track in the closing minutes of qualifications in 1958. However, his speed wasn't good enough to make the field. He did race in the "500" in 1955, 1957, and 1960. Russo is not driving the car in this photo.

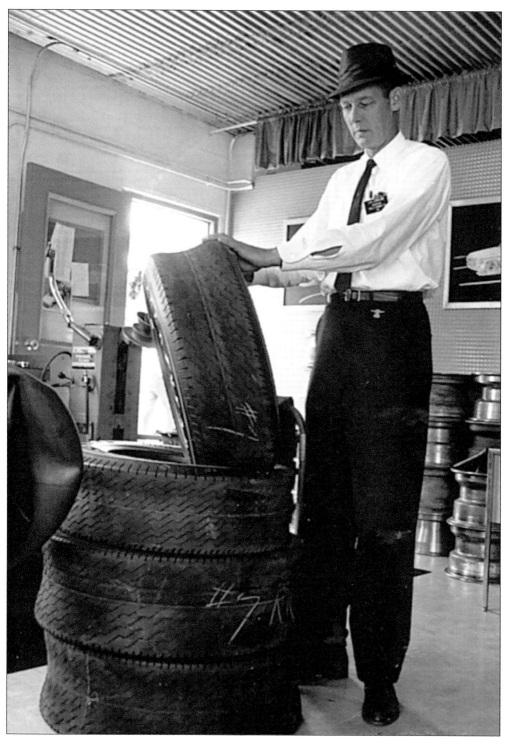

J.A. Loulan of the Goodyear Tire & Rubber Company inspects the tires from Lloyd Ruby's car. Back in 1965, they used to impound the tires following qualifying and wouldn't give them back until race day.

Harlan Fengler shows off the hardware that was found on the track during a practice. Bill McCrary of Firestone spotted the potential problem on the track after a driver reported seeing something on the track. The *Indianapolis Times* ran an article about debris on the track, but didn't run the photo Ben Lawrence took.

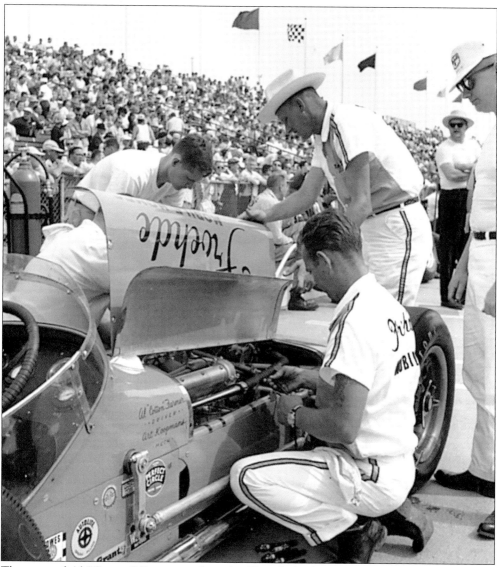

The crew of Al "Cotton" Farmer work on his Epperly laydown roadster during qualifications in 1962. Farmer didn't qualify for the race. In fact, he never qualified for any Indy 500. His mechanic was Art Koopmans. His sponsors were Froehde and Mobil. Bobby Marshman qualified as Rookie of the Year in the same car the year before.

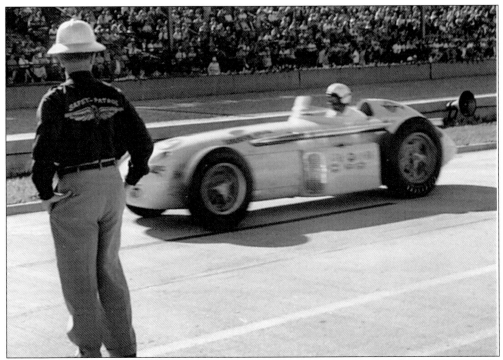

Dempsey Wilson speeds through the pits on the way to qualify for the 1958 race. He qualified 32nd and finished 15th that year after a refueling fire knocked him out. He raced in four "500s" from 1958 to 1963.

Johnny Thomson's back-up car gets a tow off the track during qualifications in 1958. He qualified in the 22nd position and finished the race in 23rd place. Walking next to the car is starter Bill Vanderwater.

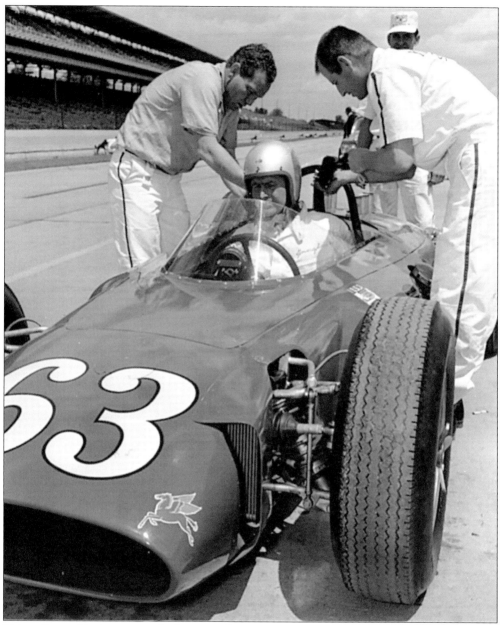

Driver Jimmy Davies gets ready for a run during practice in 1963. He failed to qualify the car that year, but he did run in four Indy 500s. His best finish was third place in 1955. Davies died in a crash in 1966 at Santa Fe Speedway in Chicago.

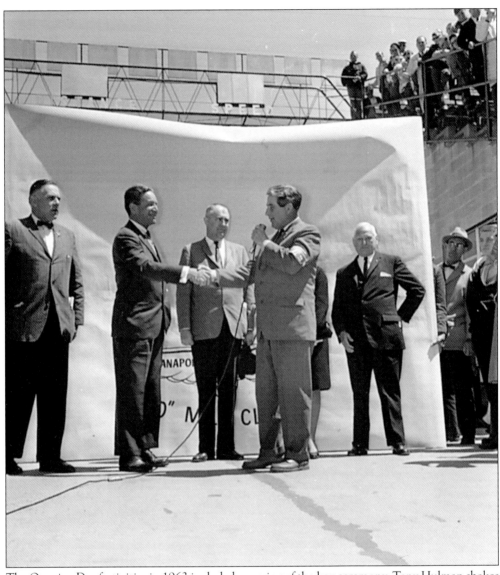

The Opening Day festivities in 1963 included a passing of the key ceremony. Tony Hulman shakes hands with Harlan Fengler, the chief steward, during the opening ceremony. Behind them is Tom Carnegie, track announcer, on the left and Bob Moorhead, president of the "500" Festival.

TWO

Race Day and Crashes

The Golden Era of Racing at the Speedway was filled with tragedy. Several drivers and even some fans were killed during the races.

In 1956, Sam Hanks and Keith Andrews tangled in front of the pits and when Johnny Thomson spun to miss the accident, he struck a mechanic working on Johnnie Tolan's car, breaking the mechanic's leg.

Early in the month in 1957, Keith Andrews was killed when he spun and hit the inside wall coming into the front stretch.

The 1958 race started on a sour note. Pat O'Connor flipped over Jimmy Reece's car and sustained fatal head injuries on the first lap. The chair reaction accident knocked 15 cars out of the competition.

The following year Jerry Unser died following a crash. He was testing a car when he went out of control on the second day of practice and was badly burned. Two weeks later he died from blood poisoning. Also meeting his fate during practice was Bob Cortner, who died when he tangled with the northeast wall.

In 1961—the Golden Anniversary of the 500—Tony Bettenhausen volunteered to test Paul Russo's car. He crashed in front of the pits and was killed.

Two years later, Jack Turner spun coming out of the fourth turn earlier in the month and rolled nine times before coming to rest. He suffered burns and a crush vertebra in the crash. The crash forced him to retire.

In 1964, Dave MacDonald's car went sideways and crashed into the inner wall coming into the front stretch on the second lap. The car burst into flames as it headed back across the track to the outer wall trailing a river of burning fuel behind it. Eddie Sachs ran into MacDonald's car and his exploded, too. Johnny Rutherford's and Ronnie Duman's cars also caught ablaze. Three other cars—Bobby Unser, Chuck Stevenson and Norm Hall—were also involved in the accident and knocked out of the race. The race was stopped for the first time in history for almost two hours. Sachs died in the crash and MacDonald died shortly thereafter. Duman was badly burned.

The Golden Era ended in 1965 on a more peaceful note. The 500 was injury free as only one accident was recorded during the race.

RACE DAY

Race Day began at 6 a.m. to allow the thousands to pour into the track in order to start the race at 10 a.m. By the way, total attendance figures for the race were top secret back then as well and never revealed to the press, but it was always in the hundreds of thousands and popularity seemed to increase every year. More seats were added each year as well.

Pre-race festivities got underway at 9:30 a.m. with a parade around the track, a launching of thousands of colorful balloons, the Purdue Marching Band playing the Star Spangled Banner and Vic Damone sang Back Home in Indiana. At five minutes before the race was to begin, a bomb went off to notify everyone. Then Tony Hulman would utter the words, "Gentlemen! Start your engines!" A pace car would parade the 33 shiny race cars around the track. Then the starter dropped the green flag to start the race.

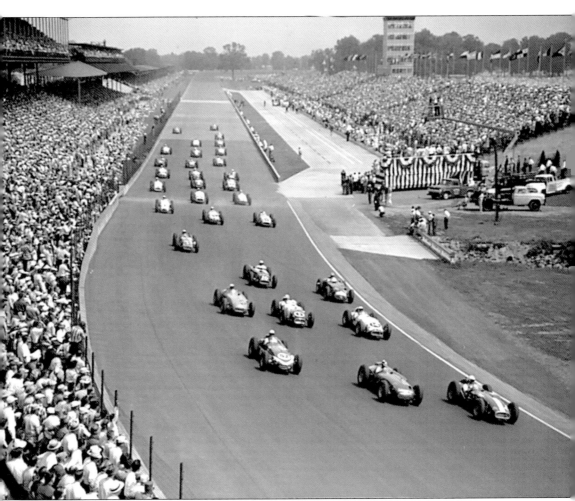

The parade lap in 1957 featured Pat O'Connor at the head of the field with Eddie Sachs in second and Troy Ruttman in third. This was the first race after the new control tower replaced the old pagoda. Fans enjoyed new seating in front of the tower in the Tower Terrace section. Sam Hanks was the winner in 1957, after starting in 13th place and leading 136 laps.

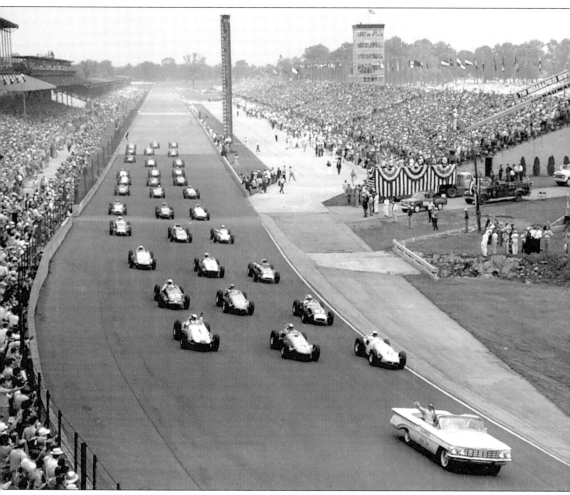

An Oldsmobile pace car driven by Sam Hanks leads the field of 33 cars for the 1960 race. During the parade lap, more action was taking place in the infield when a homemade scaffold collapsed killing two fans and injuring 40. The front row featured Eddie Sachs, Jim Rathmann and Rodger Ward. Rathmann driving in a Ken-Paul Special won the race. Victory Lane was located where the bunting is on the right.

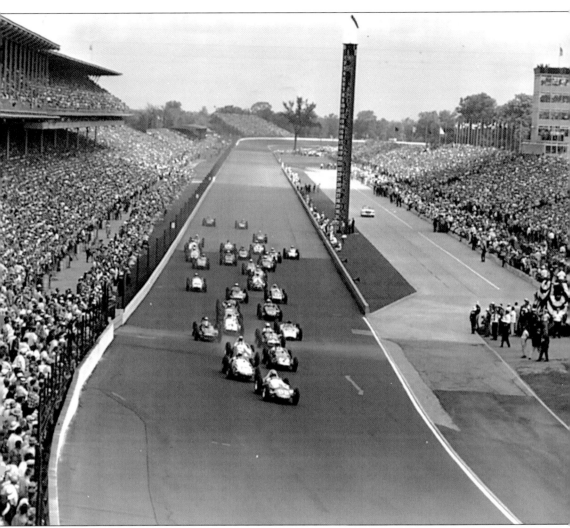

Parnelli Jones jumps out to the lead on the first lap of the Indy 500 in 1962. Right behind him was eventual winner Rodger Ward, who was driving a Leader Card 500 Roadster. Ward led 66 laps, while Jones was in first for 120 laps. In third at the start was Bobby Marshman. The pace car, a Studebaker Lark, can be seen in pit row.

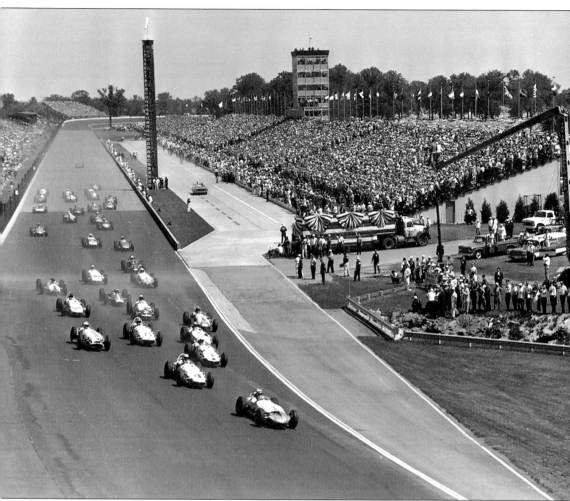

Pole winner Parnelli Jones charges out to the lead at the start of the 1963 race. Behind Jones are Jim Hurtubise and Don Branson, who were also on the front row. A little further back is Jimmy Clark in number 92, which looked quite a bit different than the Offys because it was a rear-engine car. Jones won the race, but not without some controversy. Near the end of the race, Jones was leaking oil, but track steward Harlan Fengler decided not to black flag him. Clark backed off because of the oil and finished second.

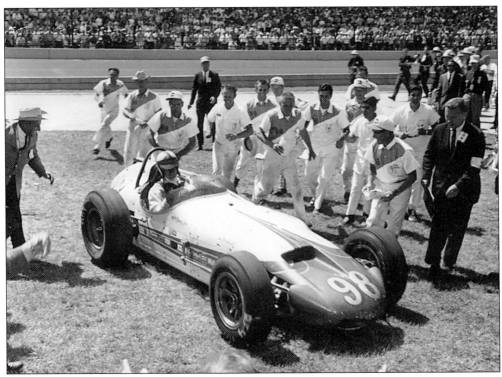

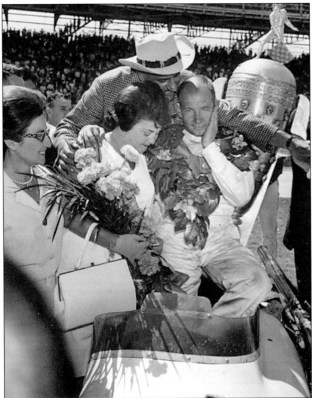

Parnelli Jones drives into
Victory Lane after winning
the race in 1963 and is greeted
by his crew, car owner J.C.
Agajanian and his wife, Grace.
Jones set the one lap record
of 151.847 to break the 150
mph barrier in 1963 with the
Agajanian Willard Special.
Then he finished in second
place in 1965. In all, he started
seven races from 1961–1967.

Crews push their cars on the track before the start of the race in 1964. Little did they know a huge crash would claim many of the vehicles at the beginning of the race.

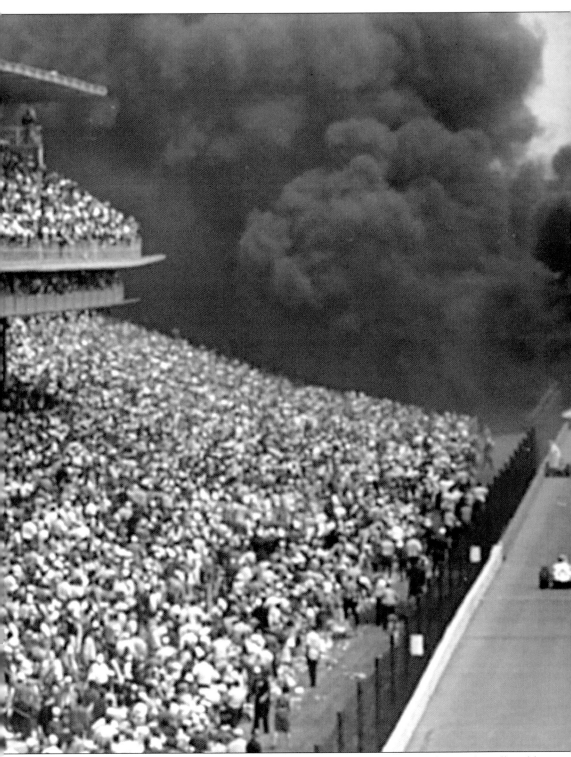

On the second lap of the 1964 Indy 500, Dave MacDonald swerved into the inside wall and his gasoline tanks exploded sending a black plume of the front straightaway. Eddie Sachs plowed into

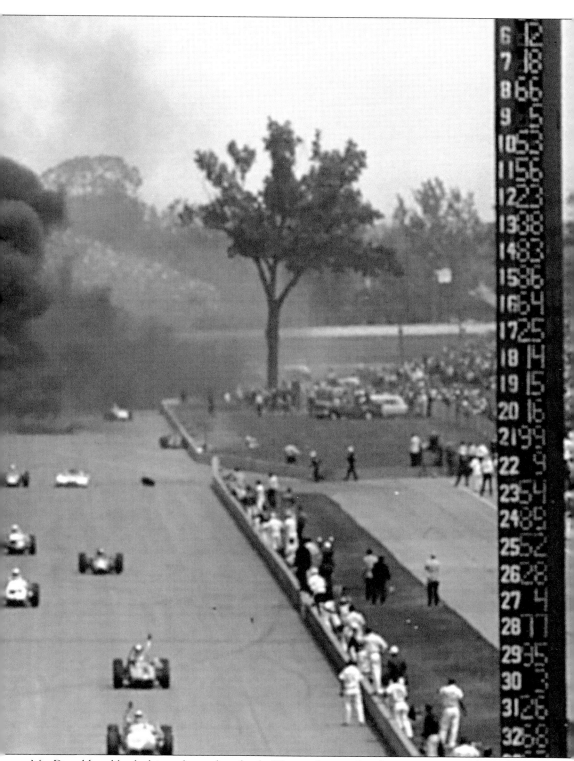

MacDonald and both drivers burned to death. The crash caused a chain reaction involving four other drivers: Norm Hall, Ronnie Duman, Chuck Stevenson, and rookie Johnny Rutherford.

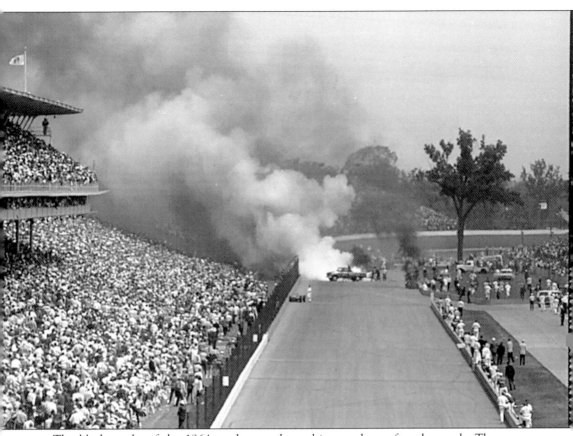

The black smoke of the 1964 crash turned to white not long after the crash. The race was postponed for the first time in history for almost two hours.

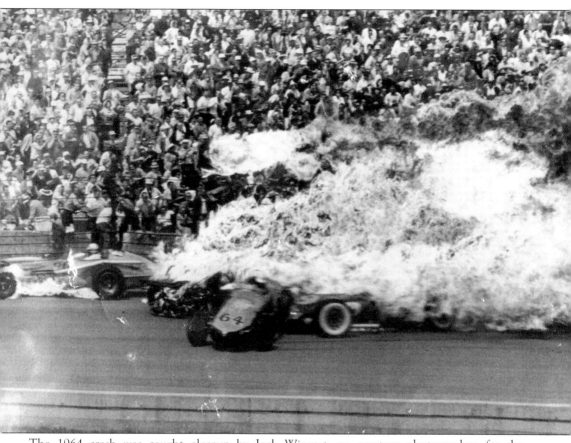

The 1964 crash was caught closeup by Jack Wingert, an amateur photographer, for the *Indianapolis Times*. Several cars were caught in the inferno caused when Dave MacDonald's car exploded. The 64 car belonged to Ronnie Duman.

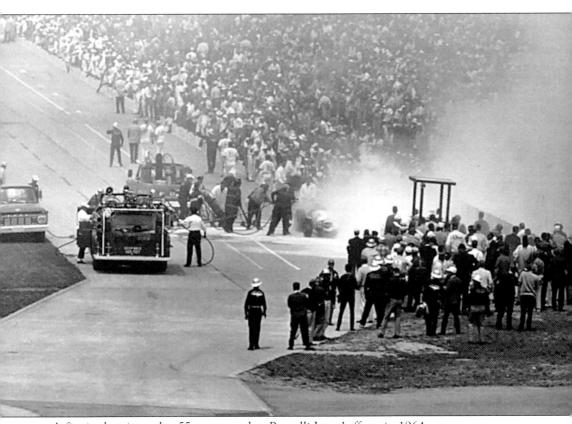

A fire in the pits on lap 55 put an end to Parnelli Jones' efforts in 1964.

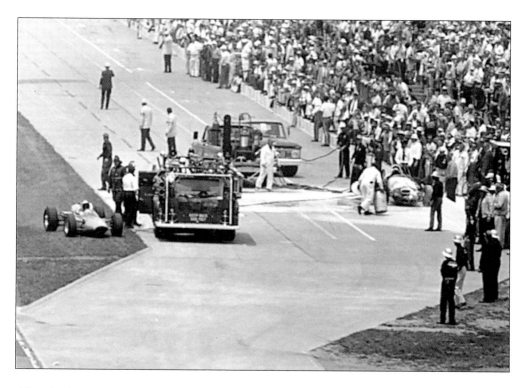

After the fire was put out, Walt Hansgen drove around the mess to get back on the track. Jones started fourth in the race and finished 23rd as a result of the fire. He was unhurt in the incident.

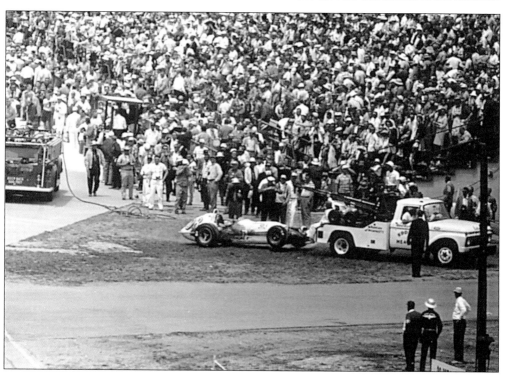

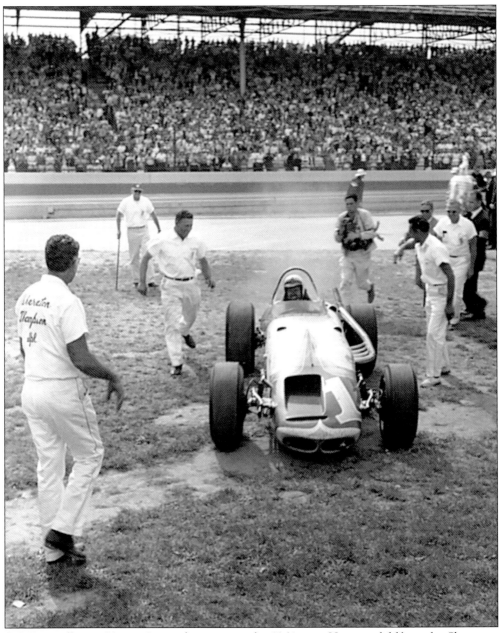

A.J. Foyt pulls into Victory Lane after winning the 1964 race. He started fifth in the Sheraton-Thompson Special. On the left is Frank Catania and in back of the car is his father, Tony Foyt.

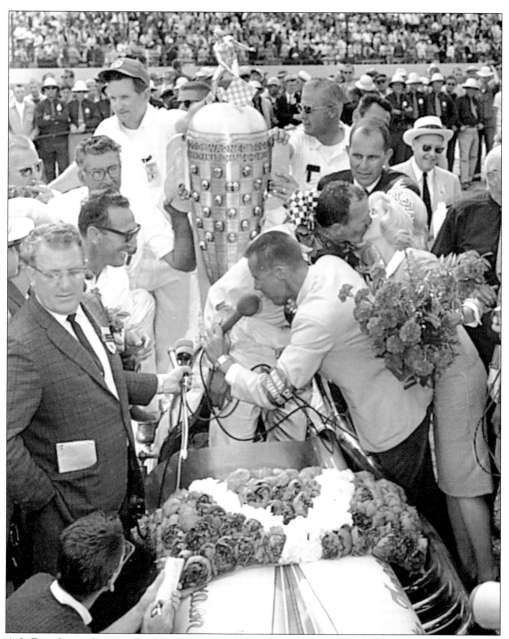

A.J. Foyt lays a kiss on the "500" Festival Queen Donna McKinley after winning the race in 1964. It was his second "500" win.

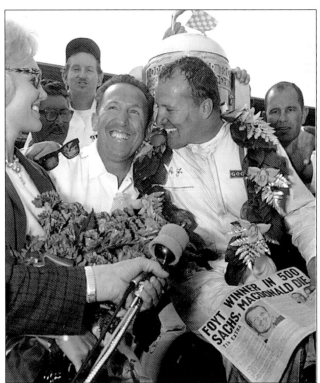

A.J. Foyt thanks his chief mechanic, George Bignotti, after the race. Bignotti helped seven drivers to the winner's circle during his time at the track. Foyt's wife, Lucy, was by his side at the winner's circle.

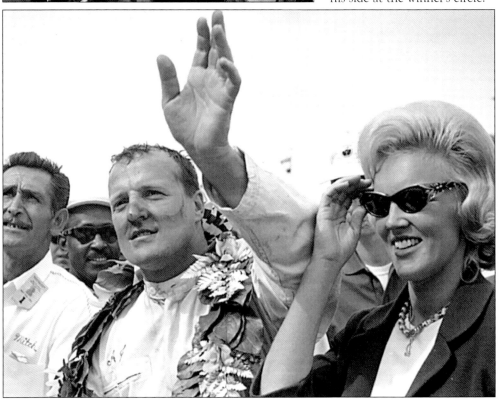

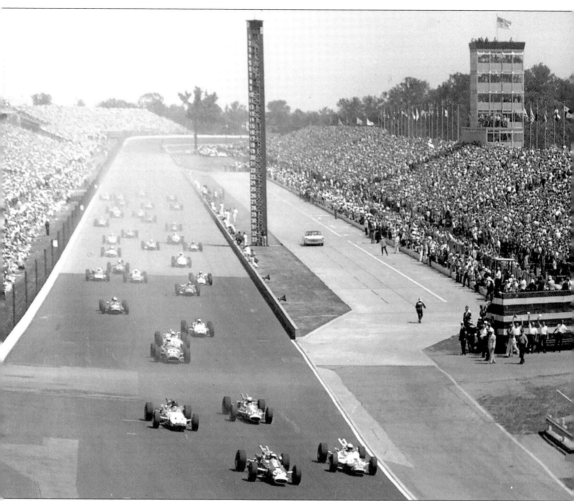

A.J. Foyt had the pole position in 1965, but not for long. Jim Clark passes Foyt on the first turn at the start of the "500" and went on to win easily. Parnelli Jones, who is in fourth position in this photo, finished second. In third place in this photo was Dan Gurney, who finished 27th after completing only 42 laps. Foyt finished 15th after getting knocked out of the race in the 115th lap due to a gearbox problem. The Plymouth pace car can be seen in the pits.

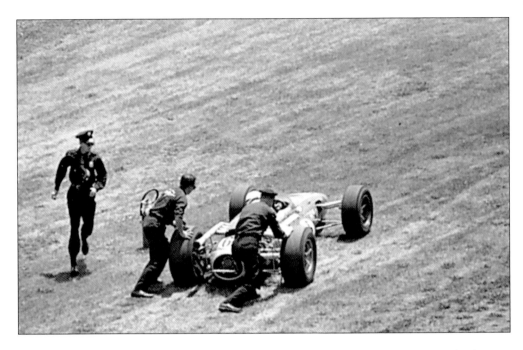

A member of the safety crew and a police officer push Ronnie Duman off the track after his rear end went out on lap 62 in 1965. Duman then stood by his car waiting for help.

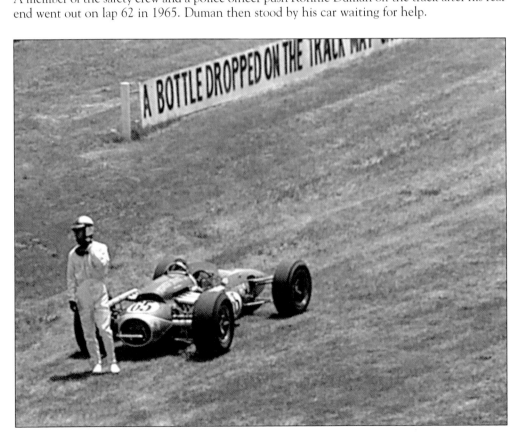

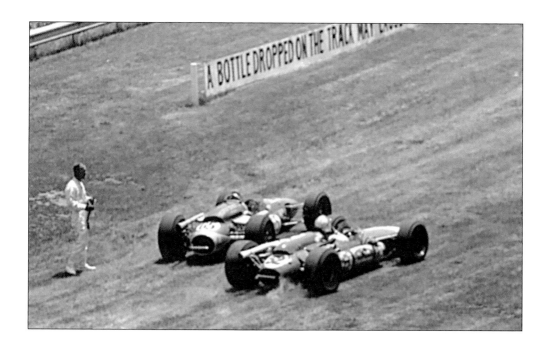

Ronnie Duman gets a visit from Jim McElreath, who went out on lap 66 from a gear chain in the 1965 race. Duman started 25th and finished 22nd, while McElreath started 13th and finished 20th. Duman decided to walk back to the pits after not getting a ride back as Bud Tingelstad drives by him.

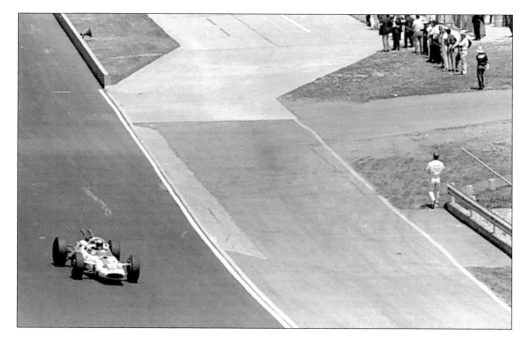

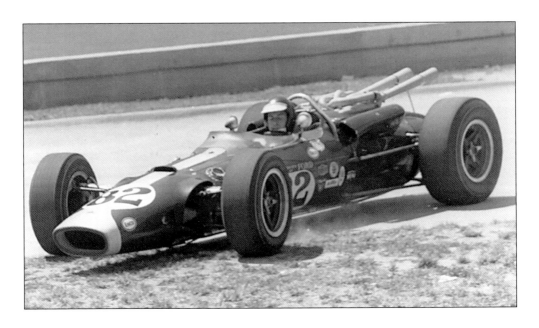

Jim Clark pulls into Victory Lane after winning the 1965 race and wreath was placed around his neck. Clark was the first driver to win with a rear-engined car to end the Offy tradition at the track. "I'd rather see it run like any other Grand Prix championship race," said Clark after the race. "Come in a couple of days early, qualify and then get on with it." Colin Chapman designed the winning Lotus-Ford.

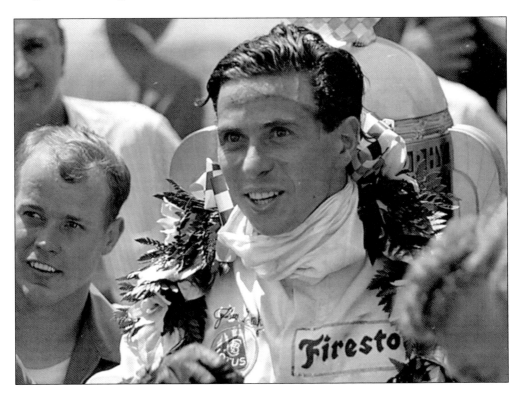

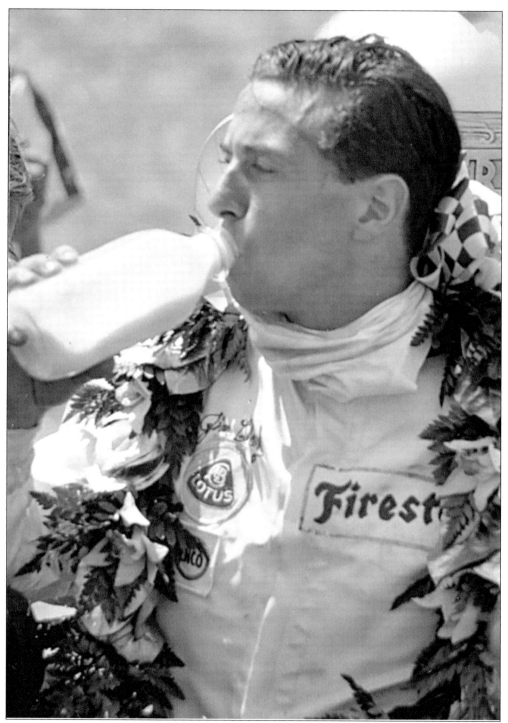

Jim Clark drinks the traditional milk after winning the 1965 race.

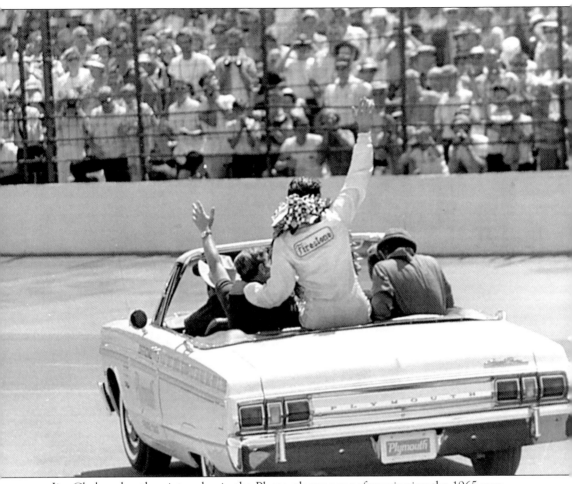

Jim Clark makes the victory lap in the Plymouth pace car after winning the 1965 race.

THREE

Drivers, Owners, and Track Officials

During the Golden Era, two drivers won two races each: Rodger Ward in '59 and '62, and A.J. Foyt in '61 and '64. Only two pole winners went onto win the race during the era: Pat Flaherty in '56 and Parnelli Jones in '63.

The Sixties brought about the rear-engined race car to Indianapolis. The first came in 1961 when Australian Jack Brabham ran a rear-engine car and finished ninth. Then along came Andy Granatelli, who brought the rear-engined Studebaker STP Novi V8 to the track. The Novi project was very unconventional because it was a four-wheel drive system. He was followed by the British invasion when designer Colin Chapman brought rear-engined Lotus cars to Gasoline Alley along with Scottish driver Jim Clark.

A.J. Watson was considered the leading car building during the Golden Era. He produced seven winners in ten years at one stretch during this time. He turned to designing rear-engined cars in the Sixties.

One of the best mechanics during the Golden Era was George Bignotti, who was A.J. Foyt's chief mechanic. In all, Bignotti walked away with seven winners during his time at the track.

WINNING DRIVERS DURING THE GOLDEN ERA:
1956 – Pat Flaherty, John Zink Special, 128.490 mph
1957 – Sam Hanks, Belond Exhaust Special, 135.601 mph
1958 – Jimmy Bryan, Belond AP Special, 133.791 mph
1959 – Rodger Ward, Leader Card 500 Roadster, 135.857 mph
1960 – Jim Rathman, Ken-Paul Special, 138.767 mph
1961 – A.J. Foyt, Bowes Seal Fast Special, 139.130 mph
1962 – Rodger Ward, Leader Card 500 Roadster, 140.296 mph
1963 – Parnelli Jones, Agajanian Willard Special, 143.137 mph
1964 – A.J. Foyt, Sheraton-Thompson, 147.350 mph
1965 – Jim Clark, Ford-Lotus, 150.686 mph

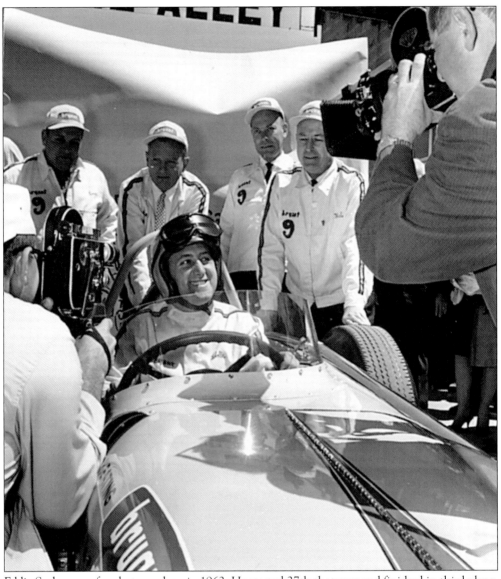

Eddie Sachs poses for photographers in 1962. He started 27th that year and finished in third place.

Eddie Sachs answers questions from Jim Phillippe in 1962. Sachs died two years later in a crash at the Speedway, while Phillippe passed away in December 2003.

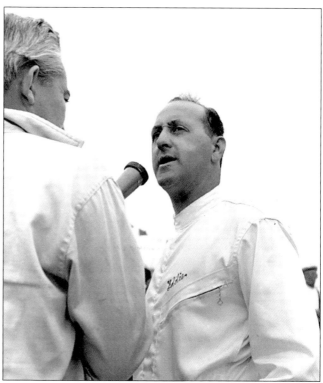

When Eddie Sachs got married, Ben Lawrence was on hand to take photos of the wedding.

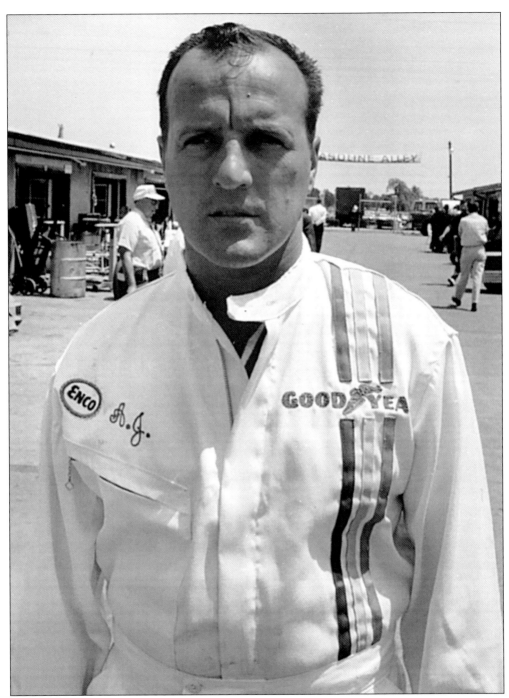

A.J. Foyt stopped to allow Ben Lawrence to take his photo in 1965 in Gasoline Alley. Foyt won two races—1961 and 1964—during the Golden Era at the Speedway. He first win came in 1961 in a front-engined Offenhauser Bowes Seal Special with an average speed of 139.130 mph. Then he won the 1964 race in a front-engined Sheraton-Thompson with an average speed of 147.350 mph. It was the last time a front-engined Offy won the race. Foyt is now an owner and still runs cars every May at the Speedway.

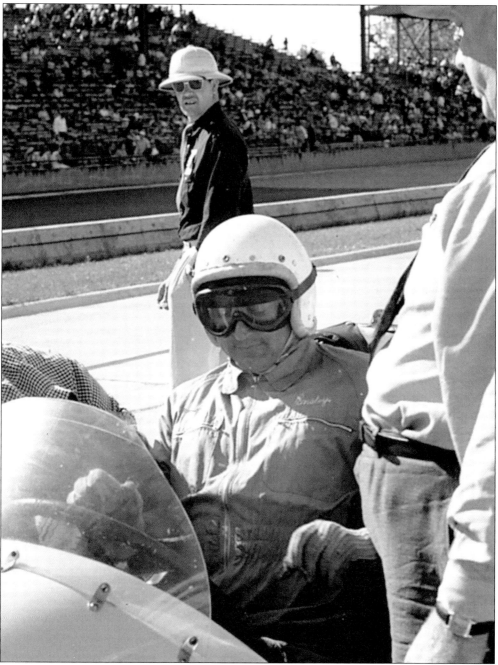

Jack Ensley gets into his car in an attempt to qualify for the 1958 race. The local business owner tried three more times to qualify a car for the race, but he was unsuccessful.

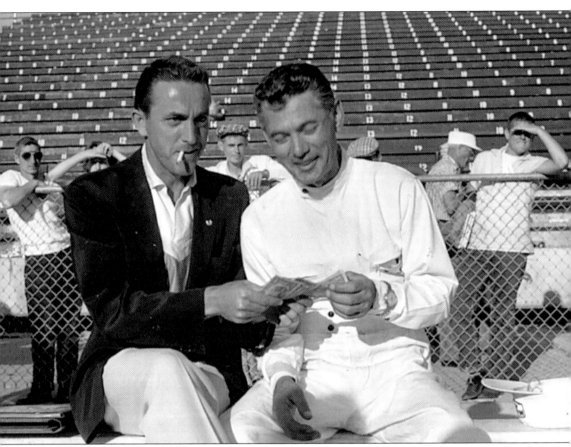

Driver Freddy Agabashian gets paid in 1958. He attempted to qualify a car sponsored by the city of Memphis that year, but was unsuccessful. He started 11 "500" races and his best finish was fourth in 1953.

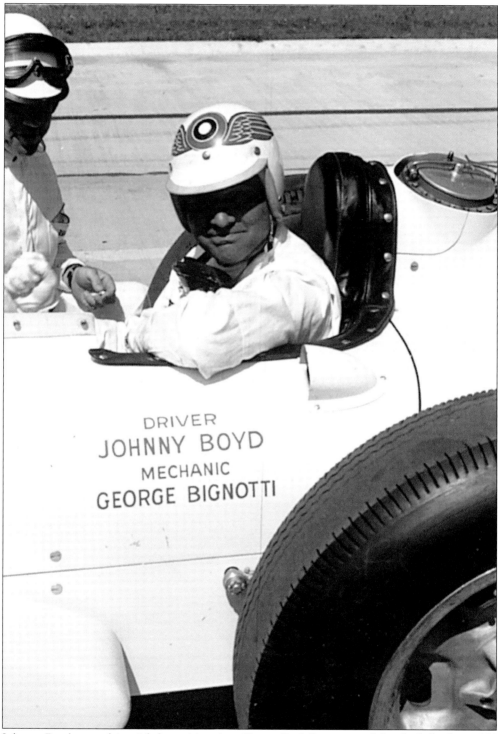

DRIVER
JOHNNY BOYD
MECHANIC
GEORGE BIGNOTTI

Johnny Boyd started in eighth position in a Bowes Seal Fast car and finished third in 1958 when this photo was taken. That was his best finish ever during his dozen years at the Speedway (1955–1966). George Bignotti was his chief mechanic.

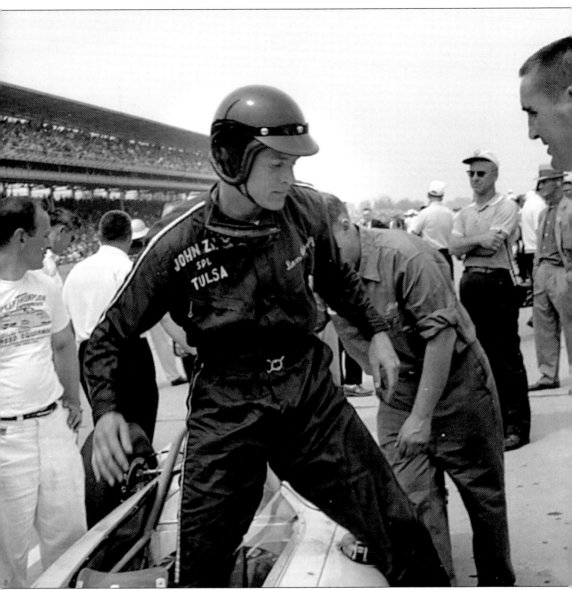

Dan Gurney gets out of his car during qualifications in 1962. He was a rookie that year at the track and finished in 20th place. He started nine "500" races during his career and finished second twice. He also was a Grand Prix driver and won four races during an 87-race career.

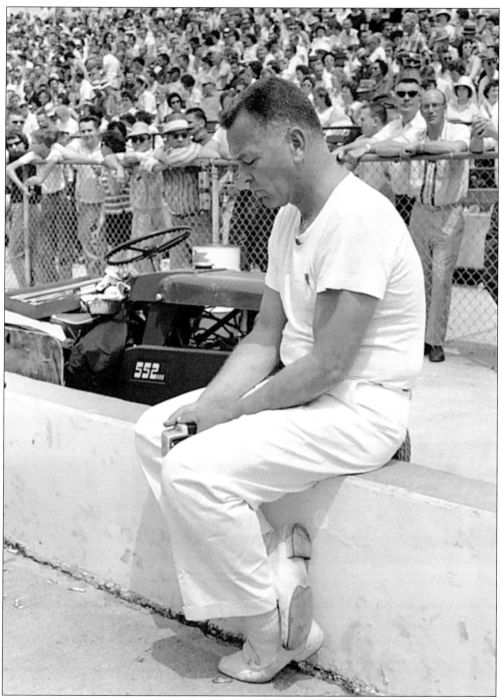

Driver and car owner Ray Crawford sits in the pits during qualifications in 1962. He didn't make the race that year, but he drove in three other "500" races.

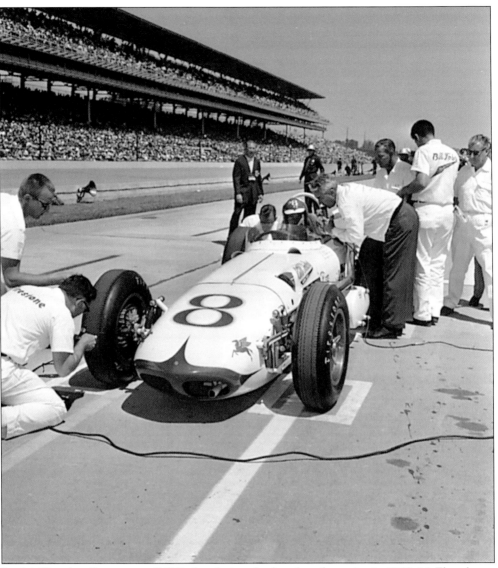

Jim McElreath talks to owner Bill Forbes during the first day of practice in 1963. McElreath was a regular at the Speedway during the 1960s and 1970s. He started in 15 races during that time. His best finish was third place in 1966.

Bobby Marshman waves to his fans from his Bryant Heating & Cooling car, which started in the third pole position in 1962 and finished fifth that year—his best finish at the Speedway. Behind him is his chief mechanic Joe Langley. Two years later, he died in a crash while testing a car in Phoenix. Marshman started four Indy 500 races altogether before he met his fate. Below, he is with his teammate, Al "Cotton" Farmer.

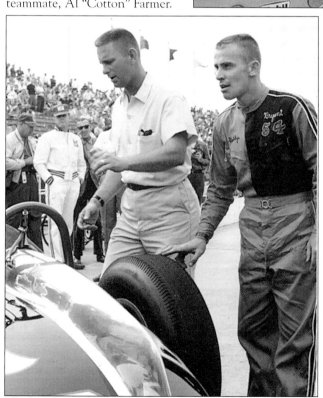

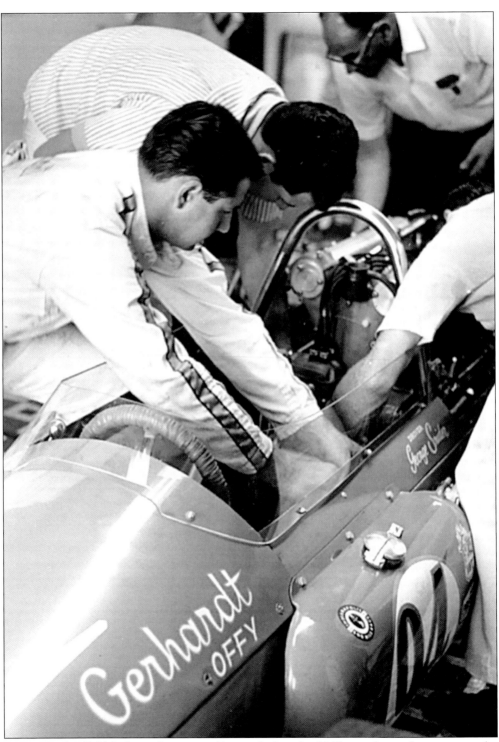

George Snider (left) helps with repairs of his car before the 1965 race, his rookie season at the track. He started 16th that year and finished 21st. Snider started 22 "500" races and his best finish was eighth place coming in 1975 and 1978.

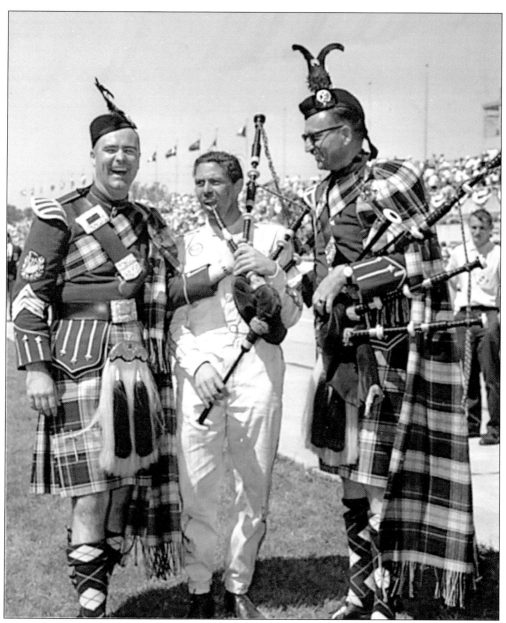

Jim Clark plays the traditional bagpipes after the running of the 1963 race. The Scotsman was part of the international invasion that came to the Speedway in the 1960s. He started in five Indy 500s and won the race in 1965 in a rear-engined Ford-Lotus. Clark then turned to becoming the Formula One world champion that same year. He died in 1968 in a crash in Hockenheim, West Germany.

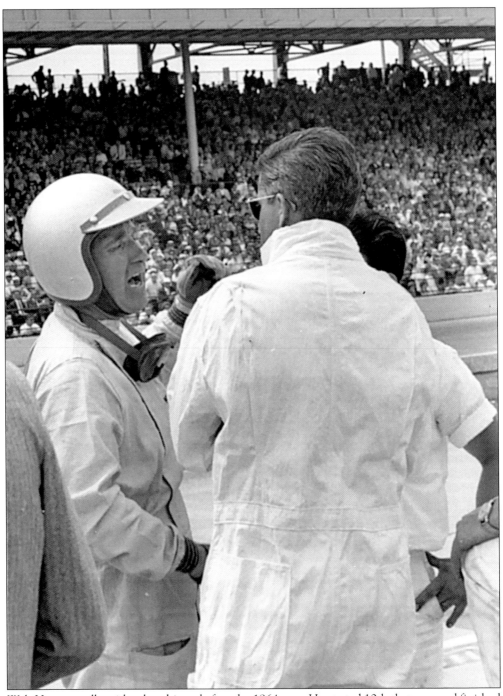

Walt Hansgen talks with other drivers before the 1964 race. He started 10th that year and finished 13th. He also raced in the 1965 "500," finishing 14th. He died in 1966 during testing at LeMans.

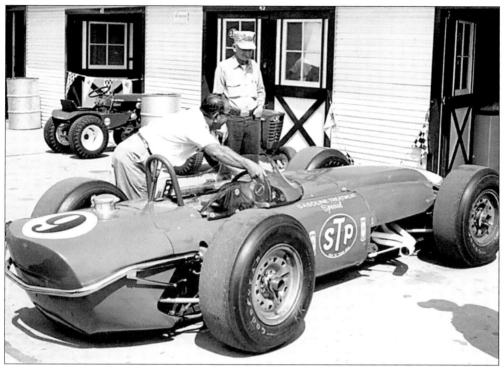

The STP crew pushes Bobby Unser's STP-Gas Novi car into the garage for more work before the 1965 race. The car started eighth and finished 19th. It was knocked out in the 69th lap from an oil fitting problem. Below, Ben Lawrence then took a photo through the tail cone into the engine compartment.

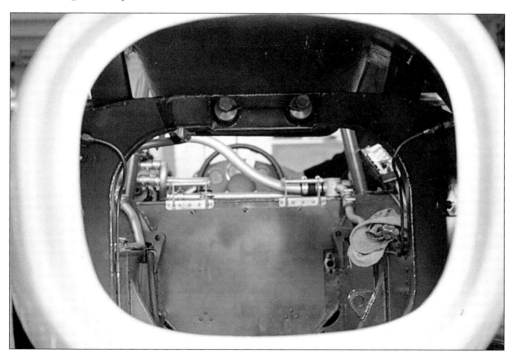

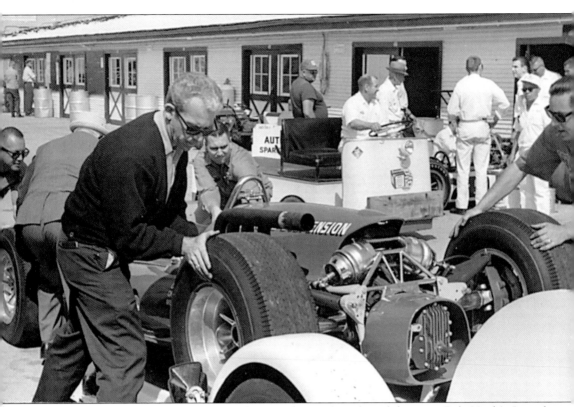

"Everybody push on the count of three!" That's what they did to get Bob Veith's Liquid Suspension car in Gasoline Alley in 1965. Veith ran in 11 races between 1956 and 1968. He finished 24th that year after a piston failure.

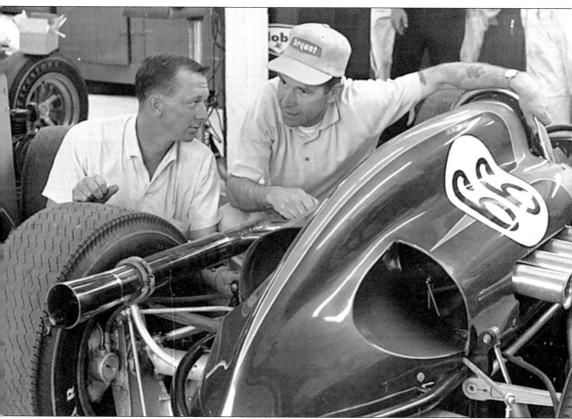

Billy Foster talks with fellow driver Len Sutton about his Autotron Electronic car in his garage before the 1965 race. He started sixth that year and finished in 17th after a water line failure. He also raced in the Indy 500 in 1966 and finished 24th. Foster died in a crash in 1967 at Riverside, California.

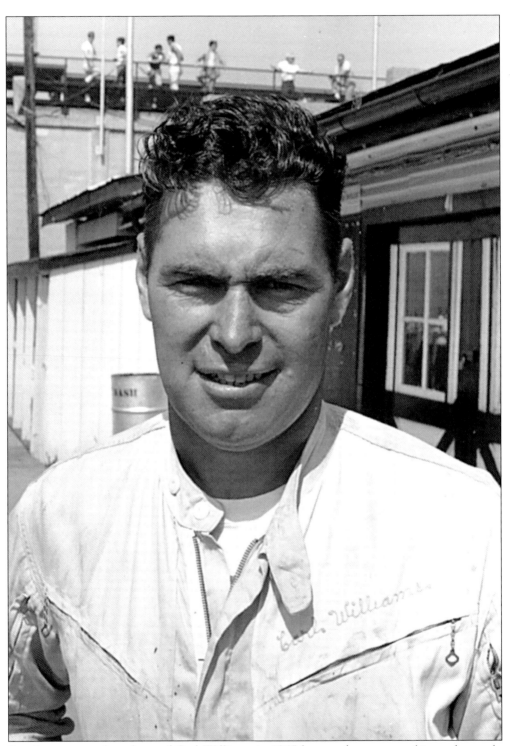

Ben Lawrence took a photo of Carl Williams in 1965 because he was a rookie at the track. Williams didn't get to start that year and became a true rookie the next year. He raced in the Indy 500 for seven years (1966–1972). His best finish was ninth in 1970.

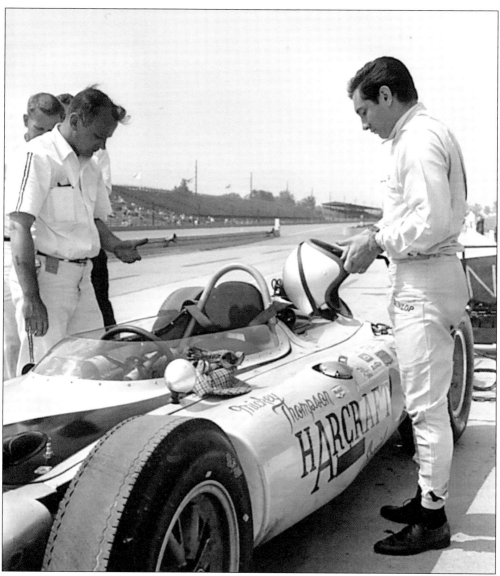

Driver Pedro Rodriguez gets ready for a run in the Harcraft Special. The Grand Prix driver never qualified for the race.

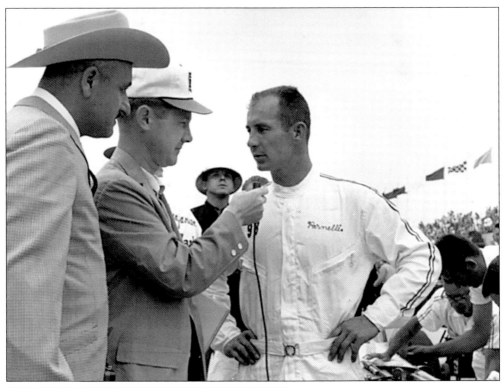

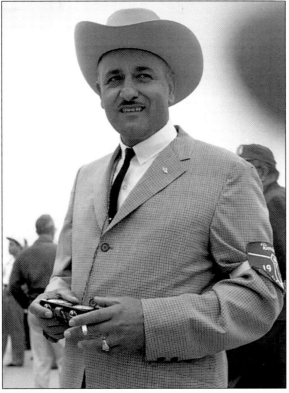

Bill Donnella interviews Parnelli Jones as owner J. C. Agajanian observes. Agajanian was an owner during the entire Golden Era. In fact, Agajanian ran cars at the track from 1948 to 1971 and recorded two wins, three poles and four track records. The race promoter briefly dabbled in Europe's Formula One racing as well. He was known for his Stetson hats and alligator boots, but he wasn't from Texas; he was from southern California. "Aggie" used to raise hogs before he started racing cars.

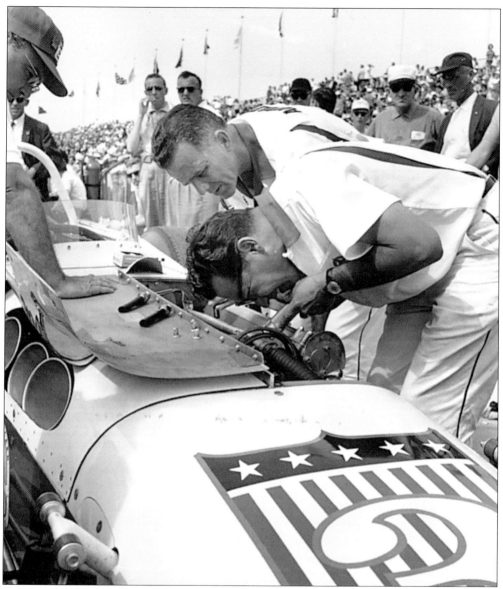

Autolite Spark Plug technicians work on Rodger Ward's winning Leader Card 500 roadster in 1962.

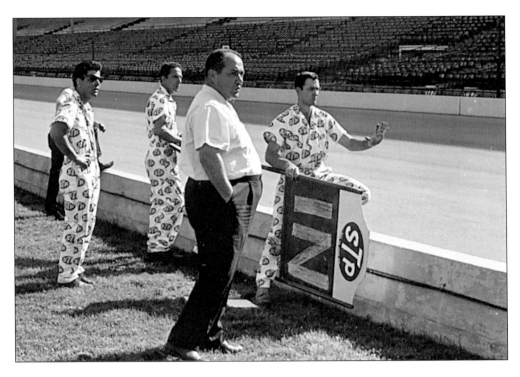

STP crew member Ron Falk tells a driver to stop as owner Andy Granatelli watches the action. Granatelli began coming to the track in 1963 with the rear-engined Novi. He encountered nothing but trouble at first and had a lot of hard luck with his cars, but he later became a winning owner at the track. Below, the crew pushes a STP-Gas Novi back to a wet Gasoline Alley.

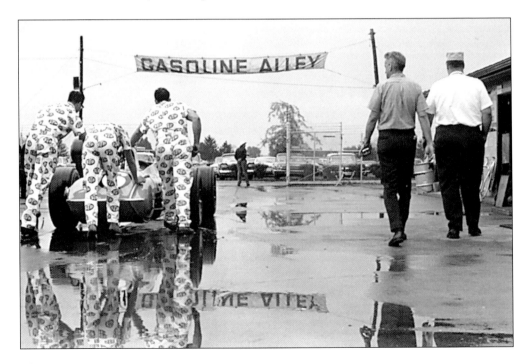

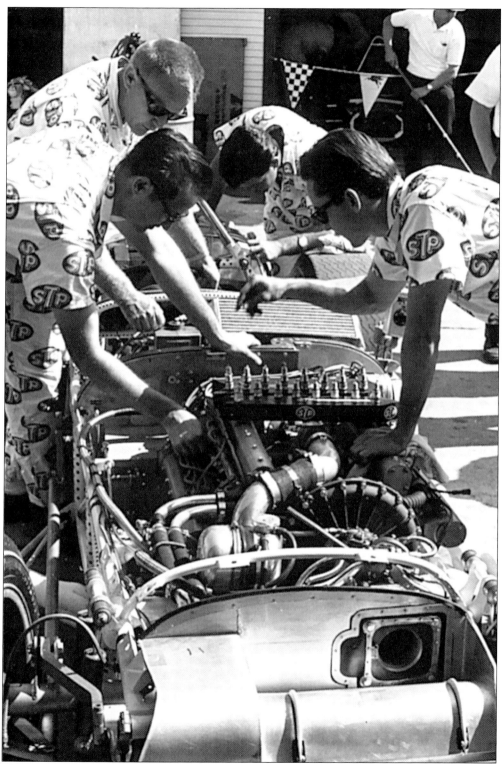

The STP crew works on the Novi in 1965.

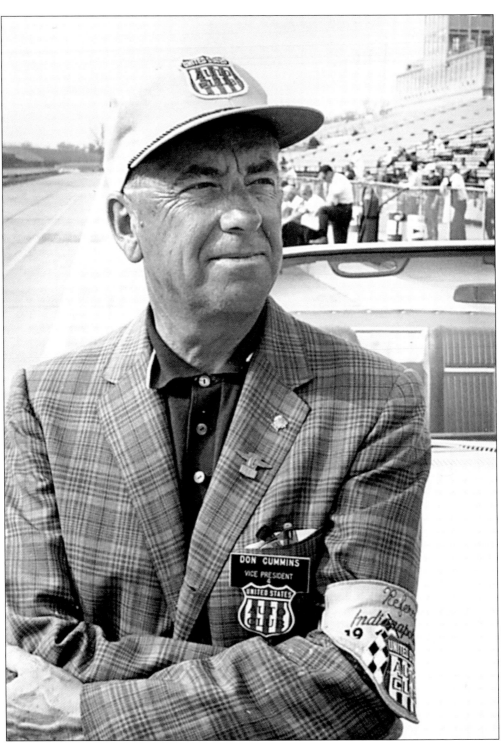

Don Cummins was the vice president of the United States Auto Club during the Golden Era. He worked some 15 years for USAC. He brought the Cummins diesel to the track in 1952 and Freddie Agabashian.

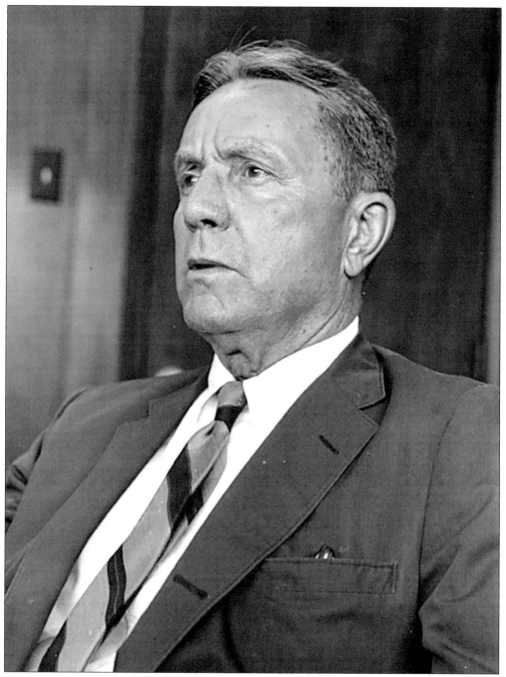

Ben Lawrence took photos of Tony Hulman while he answered questions during an interview.

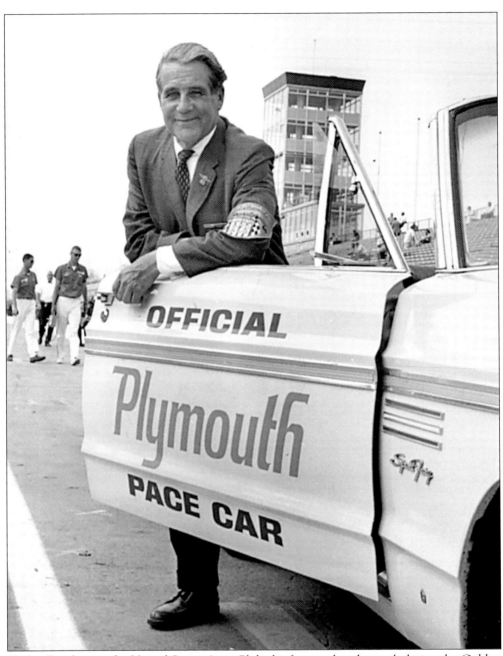

Harlan Fengler was the United States Auto Club chief steward at the track during the Golden Era and posed for Ben Lawrence by the Plymouth Sport Fury pace car. He ran the show to 1973. Fengler was a former driver and drove in the 1923 "500," finishing 16th. The following year he wrecked during practice and broke a collar bone.

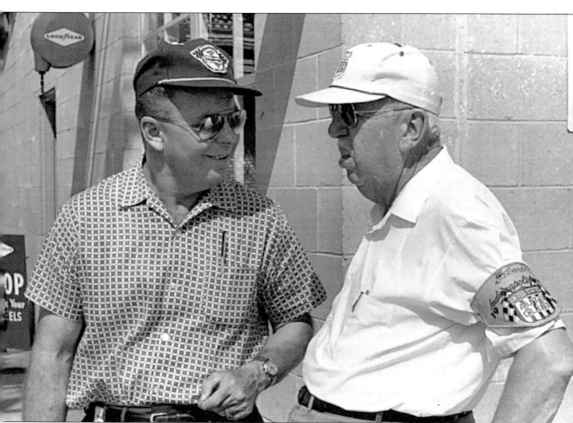

Driver Cliff Griffith talks with United States Auto Club steward Paul Johnson in 1965 in Gasoline Alley. Griffith started four races between 1951 and 1961. His best finish was ninth in 1952. Johnson saw the first "500" race at the Speedway in 1911.

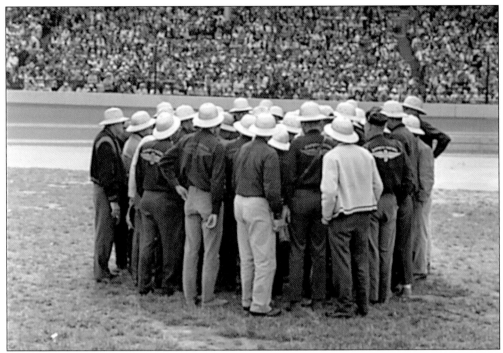

The safety crew huddles for a meeting immediately after the 1964 race at Victory Lane.

The ambulance at the track was busy during the Golden Era as many crashes occurred.

Four

Parades and Queens

The 500 Festival and Parade first began in 1957. The idea came from the Shrine Horse Patrol after they went to Louisville and saw what was being done for the Kentucky Derby. "We yakked about the idea all the way back to Indianapolis from Louisville," recalled Cecil Byrne. "We had a perfect excuse for having a parade, but it wasn't created in our opinion just to sell the 500. The 500 doesn't need selling. It was to make Indianapolis a more enthusiastic town." The festival was arranged by 33 directors—"33" was the magic number in those days—and Sam J. Freeman, a local store executive, was named as president.

The first parade in 1957 was hastily put together and only 20 floats were ready instead of 33. Television star Hugh O'Brien, who played Wyatt Earp on the western series, was the attraction for the event. More than 150,000 people lined the streets to view the parade, which was held in the evening. The festival activities that first year included the parade, a pre-parade memorial service, a post-parade square dance and invitational ball. Mel Blanc, the voice of many cartoon characters, rode in the parade as did Shirley MacLaine.

A year later, a Mayor's Breakfast for visiting dignitaries was added to the agenda as well as a Governor's reception before the invitational ball for the general public. The parade, which had the theme of "Spectacle of Speed," lasted two and half hours and attracted a quarter of a million people. The best float in the parade was a replica of the Wilbur Shaw Memorial Hill by Allied Florists. Programs were sold for the first time, so that onlookers knew what they were seeing.

Then in 1959, the two balls were combined into one and the first 500 queen was selected among 33 contestants from Indiana universities and colleges. The first was Ann Lawrie. The winners in successive years during the Golden Era were Julia Pratt, Diane Hunt, Jerilyn Jones, Linda Lou Mugg, Donna McKinley, and Suzanne Devine.

In 1960, a professional golf tournament was added to the week of festivities in the city. Doug Ford won the first tournament at the Speedway Golf Course. Arnold Palmer failed to make the cut.

By 1963, the parade had reached Rose Bowl proportions. The number of parade onlookers had more than doubled in size. Vincent Edwards, a.k.a. Ben Casey, caused the biggest stir in the parade. The TV star rode on a float with a couple of nurses from Methodist Hospital. He only made it through a quarter of the route as young girls kept charging out of the crowd to get his autograph or maybe a kiss. Other celebrities included Connie Stevens, Mickey Rooney, and Dick Crenna.

In 1964, the weeklong festival began on Monday with the Mayor's Breakfast at the Claypool Hotel. A Pro-Am Golf Tournament was held on Tuesday as well as the Mechanics Banquet that night. The $70,000 Golf Tourney began on Wednesday and the Coronation Ball was held that evening at the Indiana Roof Ballroom. On Thursday, the second round of golf was held and the parade started at 7 p.m. The third round of golf was held on Friday as was the Festival President's Reception in the Governor's Manson. The race was held on Saturday and the final round of golf was held on Sunday.

The next year the parade was moved to Saturday, the final round of golf was held on Sunday and the race was moved to Monday, May 31.

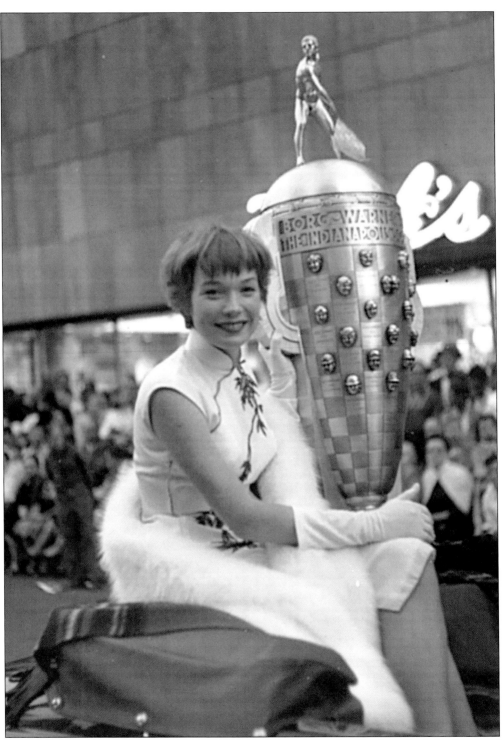

Shirley MacLaine rides in a car during the 1958 Festival Parade. She later had the honor of kissing Indy 500 winner Jimmy Bryan after the race. Movie stars kissed the winning driver starting in 1947 until 1959.

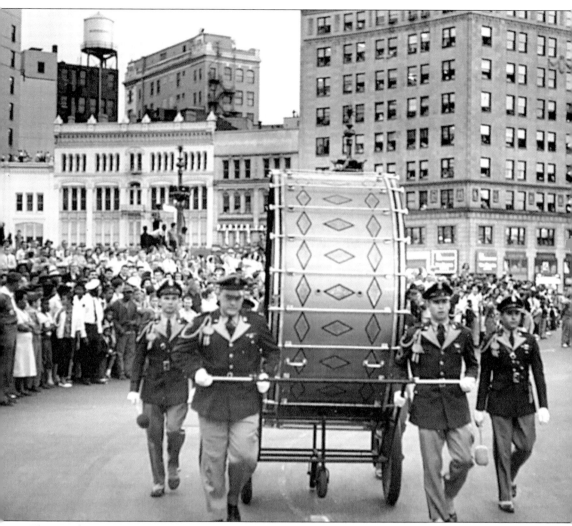

The Purdue University band pulls a huge drum during the 1958 parade. The band also performed at the track on race day.

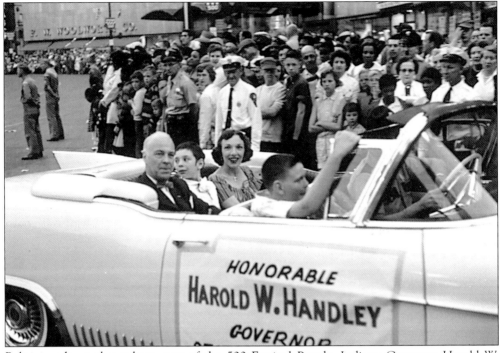

Politicians have always been part of the 500 Festival Parade. Indiana Governor Harold W. Handley was governor from 1957 to 1961 and rode in several parades. He was a candidate for the Senate in 1958 when he rode in this parade.

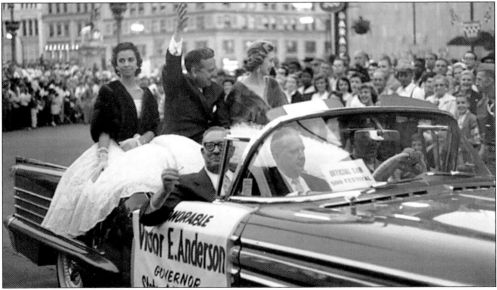

Besides the Indiana governor riding in the 500 Festival Parade in 1958, Nebraska Governor Victor E. Anderson also rode in the parade.

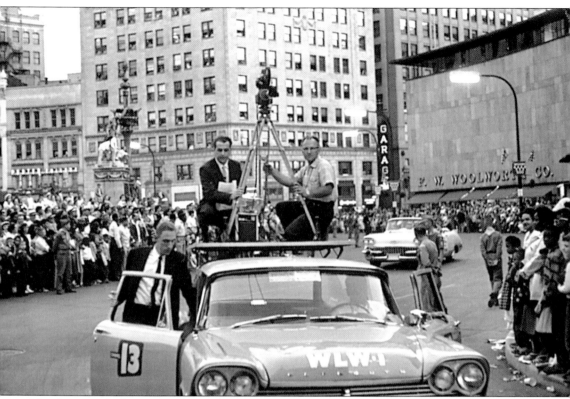

The first parade featured only 20 floats in 1957, but the 1958 parade featured many more including these. The parade began at 7 p.m. and ran well past sunset.

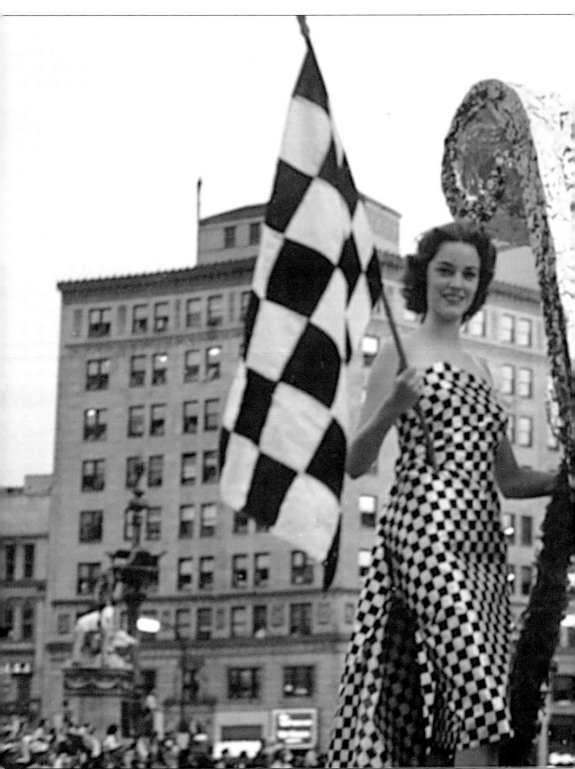

The lead float in the 1958 parade carried the theme of the parade: "The Spectacle of Speed."

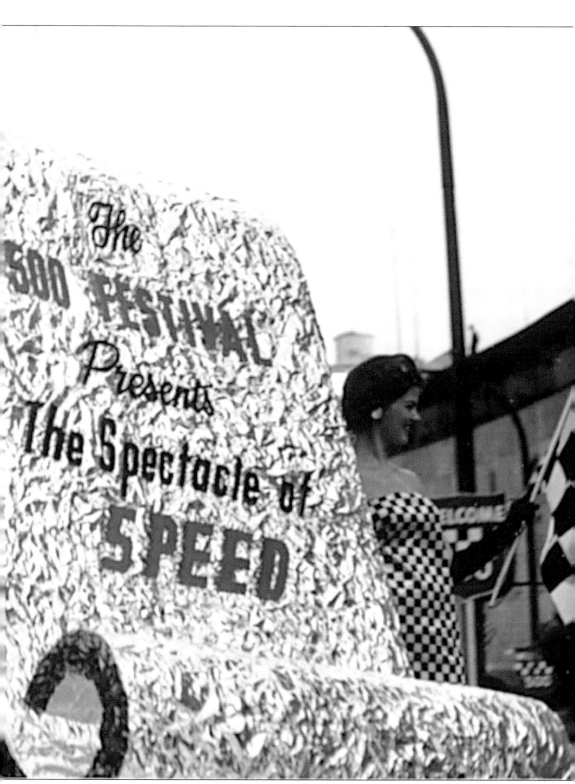

The parade lasted two and half hours and attracted a quarter of a million people.

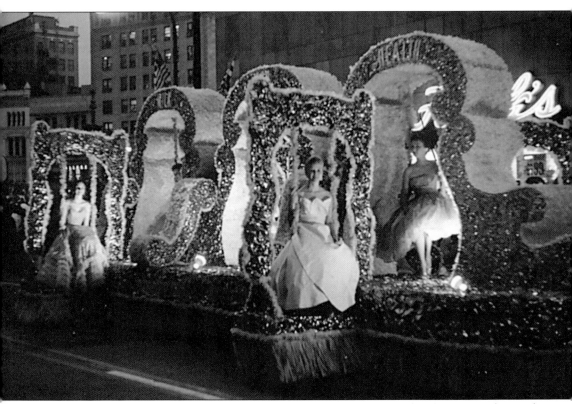

The contestants for the 500 Festival Queen rode the floats in 1958. This float passes the Hook's Drug Store, which is no longer in business.

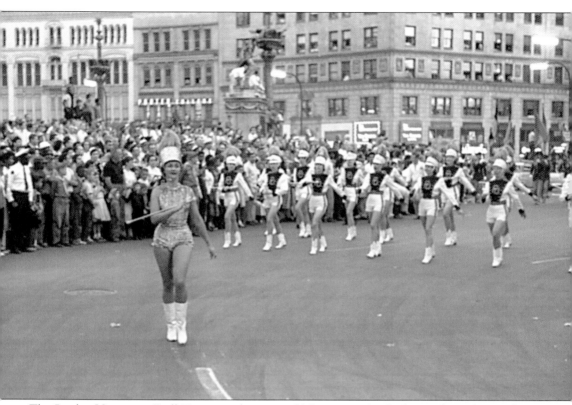

The Purdue University Drill Team marches around Monument Circle during the 1958 parade. The unit was picked as the best marching unit in the team.

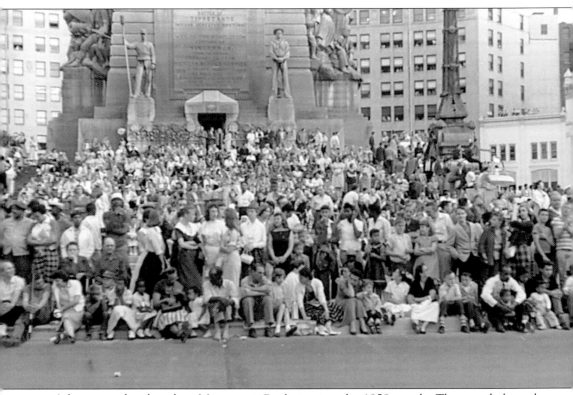

A huge crowd gathered on Monument Circle to view the 1958 parade. The crowd along the parade route swelled to a quarter of a million people.

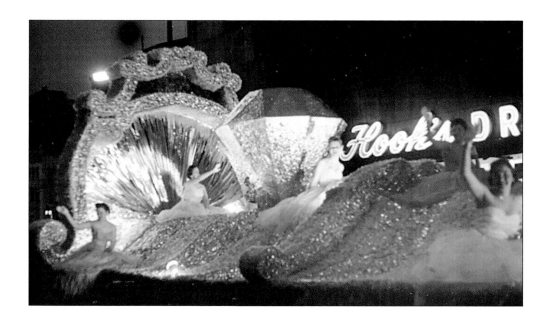

The 1958 parade featured 33 floats and was held in the evening. The parade today is held on Saturday afternoon the day before the race.

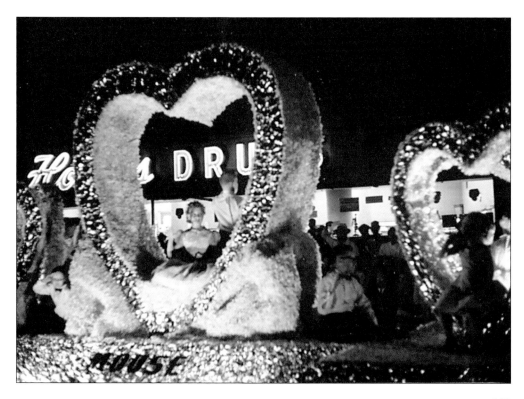

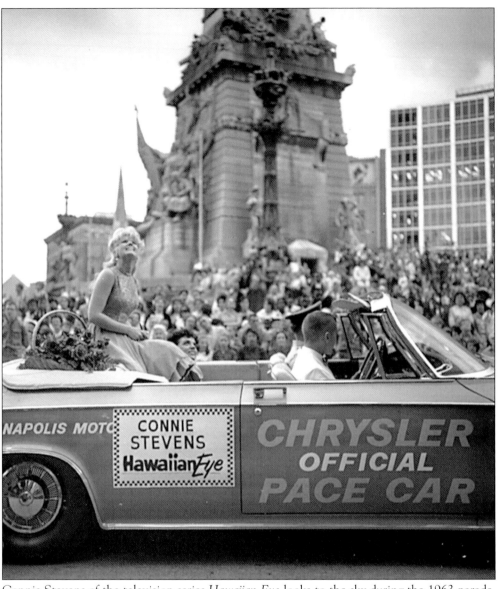

Connie Stevens of the television series *Hawaiian Eye* looks to the sky during the 1963 parade. The actress was in several TV shows and movies.

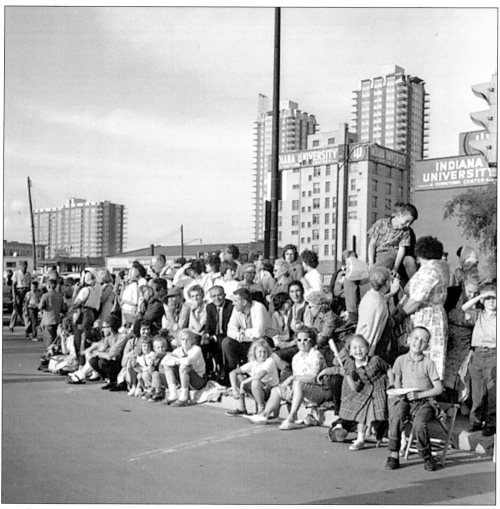

People began lining the streets of Indianapolis an hour before the parade back in 1963 during a beautiful day for a parade. People would bring their own lawn chairs as this was the day before bleachers were put along much of the route.

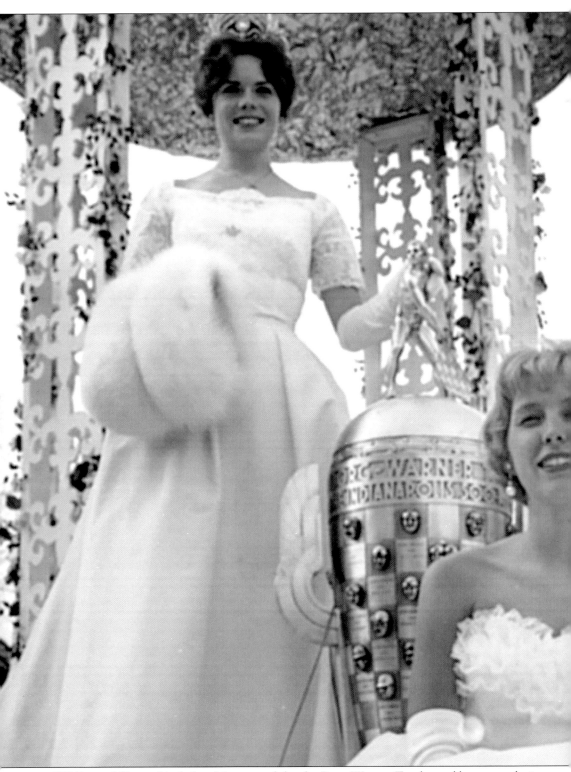

500 Festival Queen Linda Lou Mugg stands by the Borg-Warner Trophy and her court during

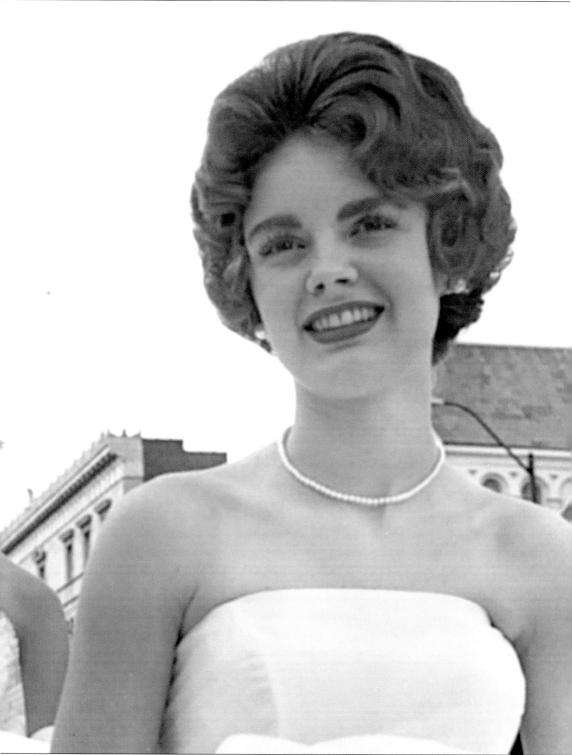

the 1963 parade.

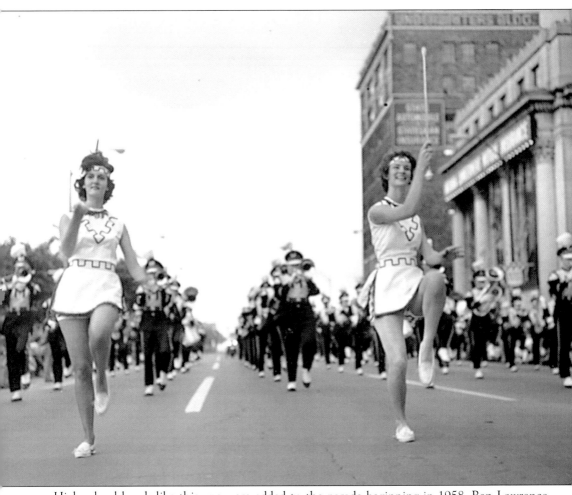

High school bands like this one were added to the parade beginning in 1958. Ben Lawrence took this photo in 1963 in the middle of Meridian Street.

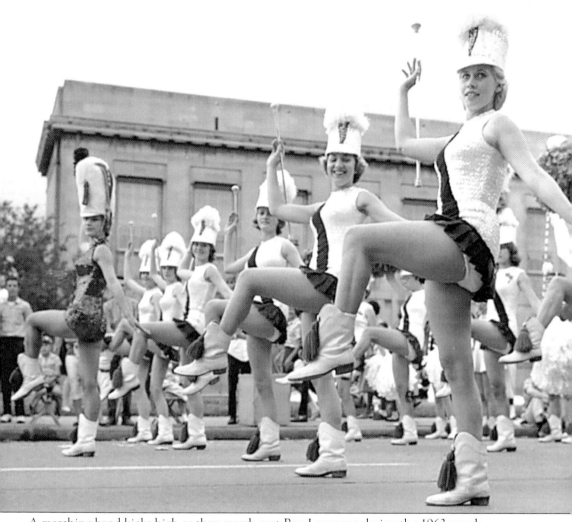

A marching band kicks high as they march past Ben Lawrence during the 1963 parade.

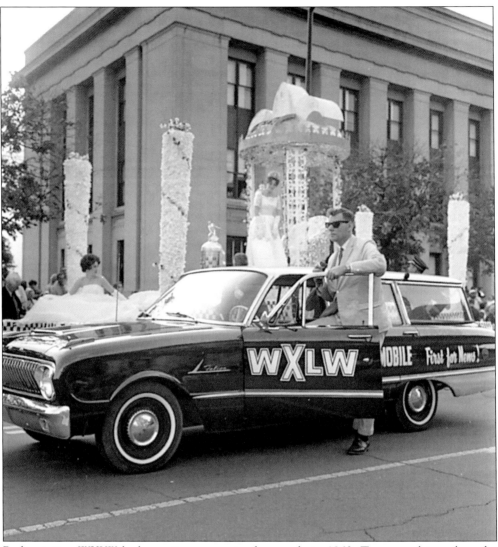

Radio station WXLW had a station wagon in the parade in 1963. Two years later when the *Indianapolis Times* went out of business, Ben Lawrence went to work for WXLW as a reporter.

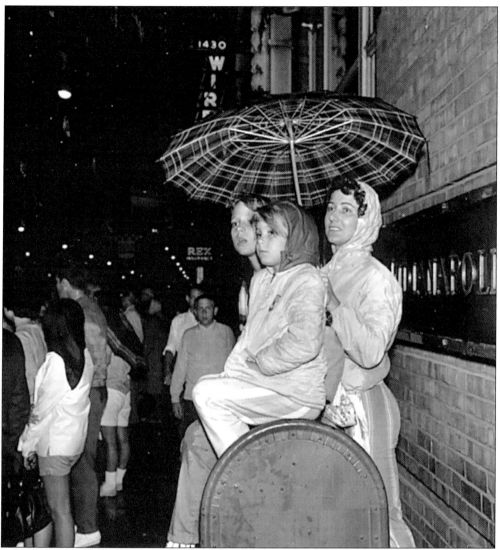

Parade goers under the protection of umbrellas in front of the *Indianapolis Star* building during the 1963 parade. In the early days, few bleachers were available for onlookers.

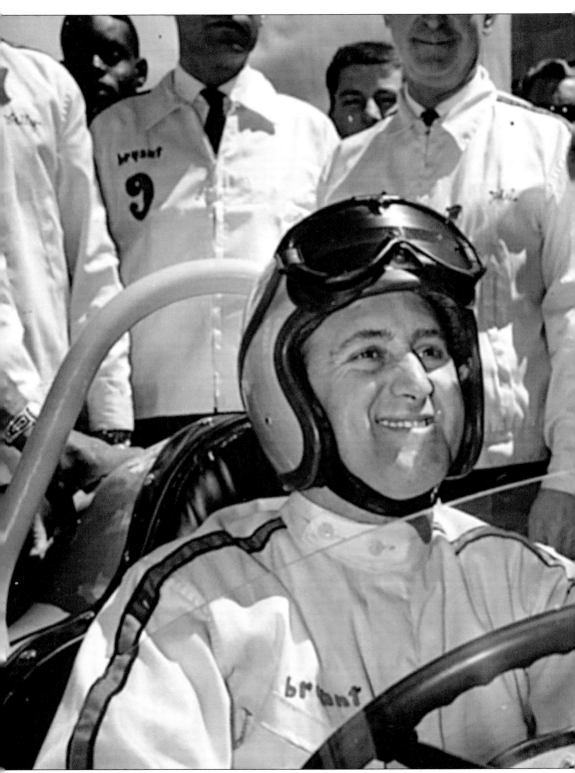

"500" Festival Queen Linda Lou Mugg poses with driver Eddie Sachs before the 1963 race.

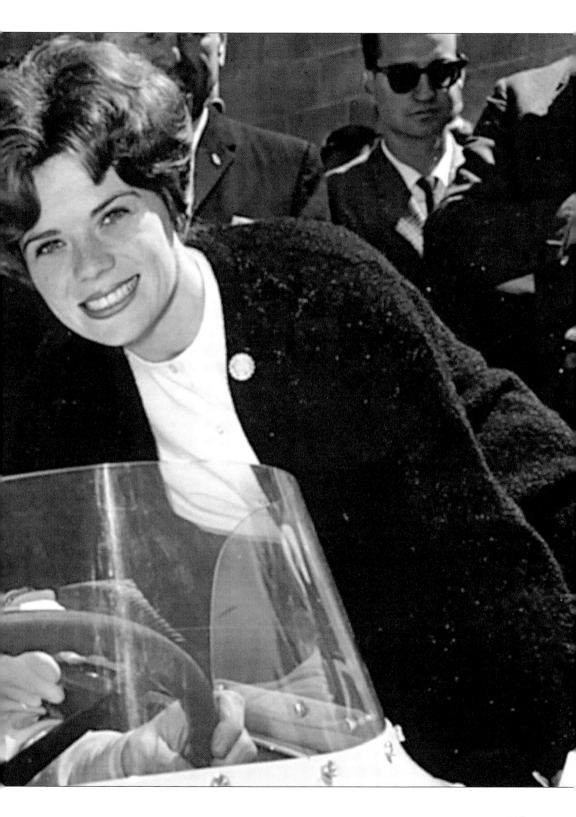

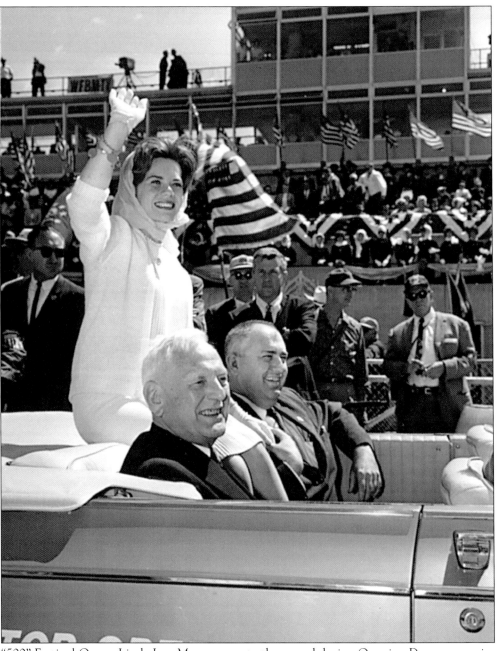

"500" Festival Queen Linda Lou Mugg waves to the crowd during Opening Day ceremonies in 1963. Riding with her are Indianapolis Mayor Albert H. Losche and Festival President Robert Moorhead.

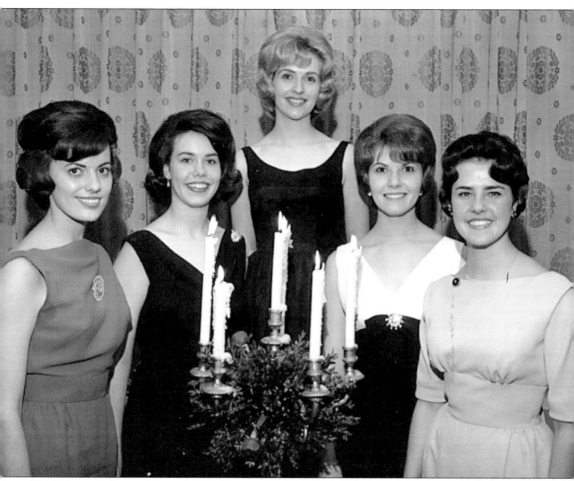

"500" Festival Queen Donna McKinley poses for photos with her court after winning the honor in 1964.

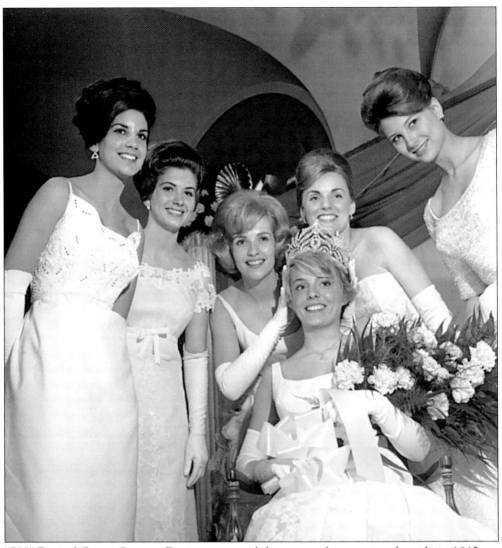

"500" Festival Queen Suzanne Devine poses with her court after winning the title in 1965.

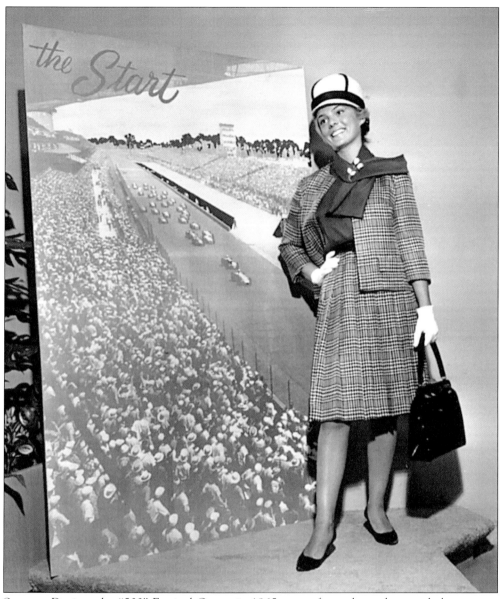

Suzanne Devine, the "500" Festival Queen in 1965, poses for a photo shoot to help promote the race.

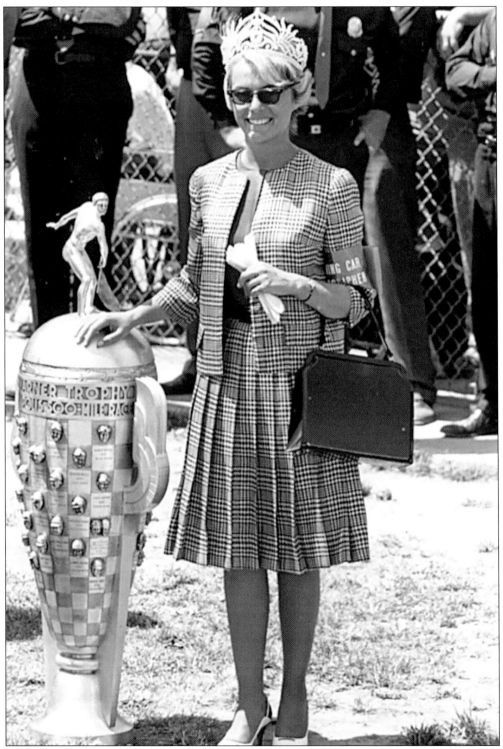

"500" Festival Queen Suzanne Devine stands by the Borg Warner Trophy to get ready for the end of the 1965 race.

FIVE

Fans and Celebrities

The fans in the Fifties must have enjoyed all the changes made at the track and the creation of the 500 Festival. The Golden Era began in 1956 with the Indianapolis Motor Speedway Hall of Fame Museum opening. The museum was located outside Gate 1 and displayed a few vintage racing cars. (The current museum didn't open until 1975.) Tony Hulman added new seating areas each year and improved the old ones as well. In 1957, the old pagoda was demolished and a new control tower was constructed. It provided a much better viewing area for officials and the press. Drivers also enjoyed some changes to the track. The home stretch was paved with asphalt expect for the strip of brick a yard wide to keep the track's integrity as the "Brickyard."

The inside of the track during the Golden Era looked like a huge parking lot. People only had to pay $10 to drive into the center to watch the race. One of the areas was called the Snake Pit, because of the activities that went on there. Too much drinking sometimes led to fights and nudity. In 1960, tragedy struck during the pace lap. A makeshift scaffold in the infield collapsed, killing two people and injuring 40. People had been charged $5–$10 to set on the privately owned scaffold to view the race.

The race attracted many celebrities during the Golden Era. Another race going on during this time was the race to space and several astronauts came to the race, including Wally Schirra and Gordon Cooper. Many television stars made their way to the Speedway in May. Dale Robertson of the Tales of Wells Fargo spent the entire month of May with the STP Novi crew. Others TV actors included Ed Sullivan, Art Linkletter, Jerry Van Dyke, Dan Blocker, Connie Stevens, Dick Crenna, Jimmy Dean, and Jack Kelly. Singers and musicians liked Indy as well, including orchestra leader Skitch Henderson, jazz clarinetist Pete Fountain, songwriter Hoagy Carmichael (who wrote Out at the Old Speedway), and singers Vic Damone and Johnny Desmond. Movie stars coming to the race included Maurice Chevalier, Erin O'Brien, Shirley MacLaine, Jimmy Stewart, Paul Newman, and Cyd Charrise. News people from media were always on hand, including such notables as Walter Cronkite.

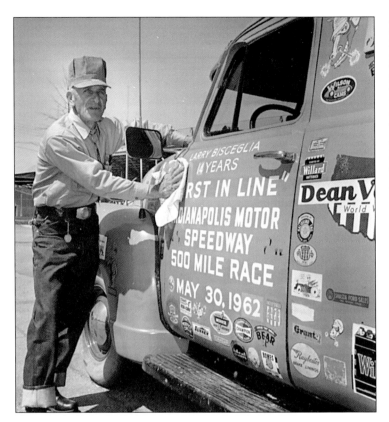

Being first in line for the Indy 500 was so important to Larry Biceglia of Long Beach, California, that he would show up more than a month before the race. After performing the feat for ten consecutive years, Tony Hulman (*below*) presented him with a silver cup in 1958, the same year he arrived on April 3. Then Sam Hanks drove him around the track while the public address announcer told everyone who he was. Biceglia continued to be first until 1986 and ill health prevented his return to the track. The Chicago native attended his first race in 1925.

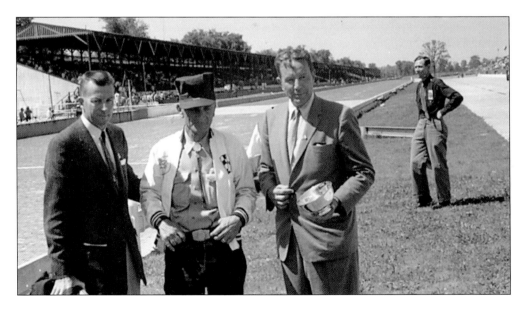

Dean Martin grabs Jerry Lewis by the nose during some of the kidding around at the track in Johnnie Parsons' Belond Exhaust car. The famous comedians appeared on television and made movies together during the Golden Era.

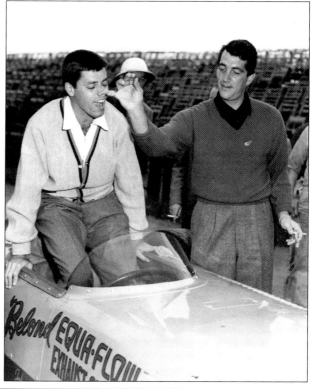

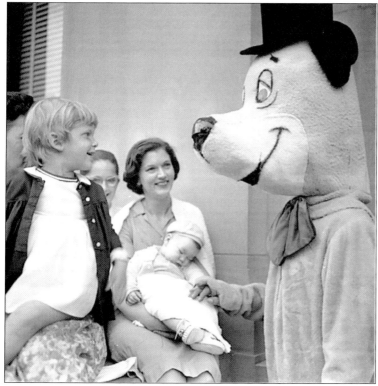

Children greet Huckleberry Hound, who was in the 500 Festival Parade on May 28, 1963.

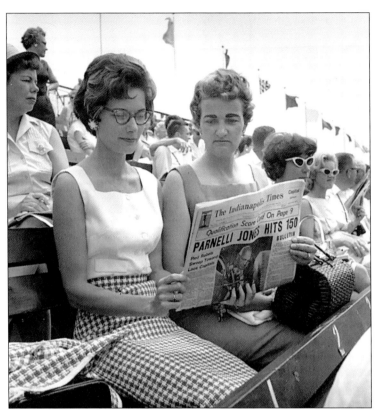

Fans read the May 12, 1962 issue of the *Indianapolis Times* during qualifications. The *Times* told the story of how Parnelli Jones hit 150 mph during qualifications.

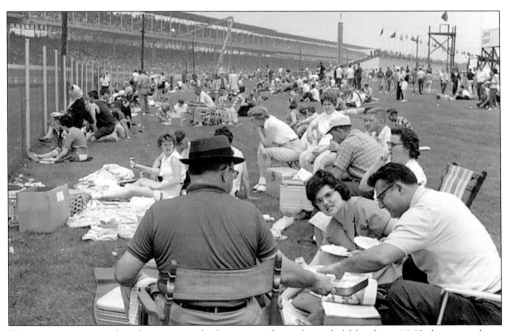

Turn one was a popular place to watch the action from the infield back in 1962, because there were no bleachers located there and people could picnic and lounge at their leisure. These photos were taken during qualifications. This area was packed during the race.

Fans got comfortable in watching qualifications back in 1963 and Ben Lawrence took photos of many of them.

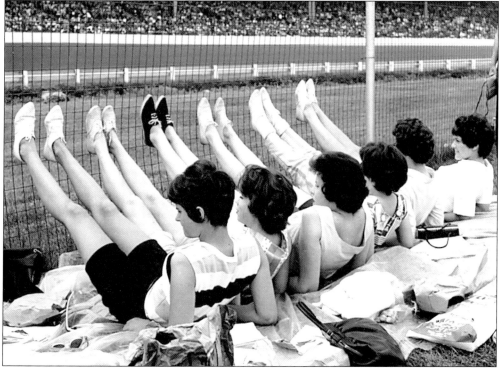

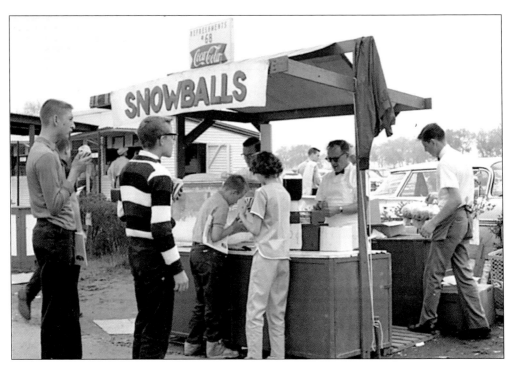

Snowballs were a popular item back in 1962 at this particular food stand. Souvenir stands were also prominent back then. Many of the wooden structures in the 1960s have been replaced by more permanent stands.

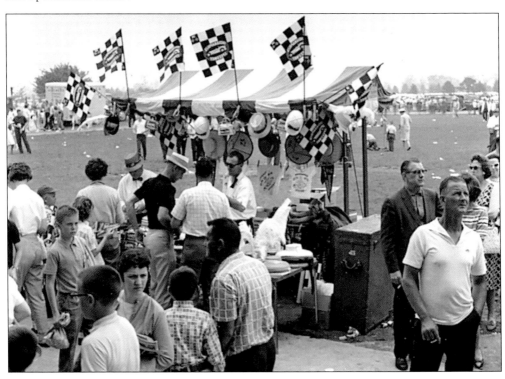

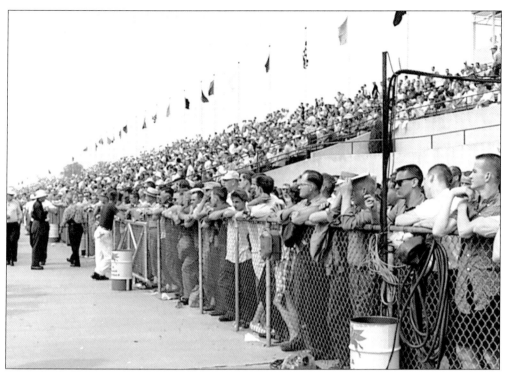

Fans who lined the fence back in 1962 were called "Railbirds."

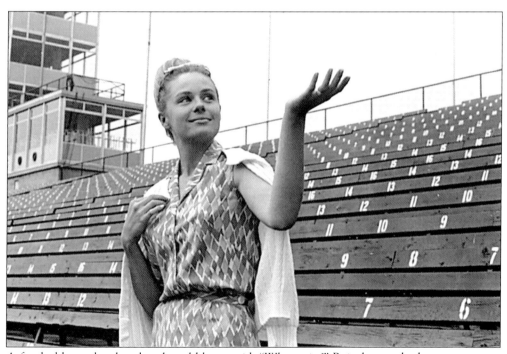

A fan holds out her hand and could have said, "What rain?" Rain has washed out some races and cut others short. The cars are not equipped to run in the rain. This photo was taken in 1965 after rain washed out a session.

Comedian Morey Amsterdam visited the track in 1962 and poses with driver Bobby Marshman. He played the character Buddy Sorrell on *The Dick Van Dyke Show* from 1961 to 1966.

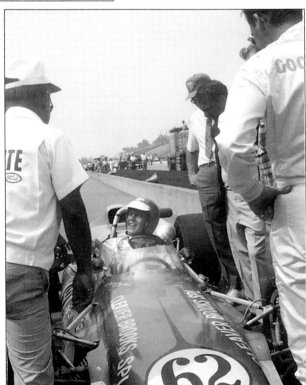

Paul Newman came to the track in 1968 for the filming of *Winning*, which starred him and Joanne Woodward.

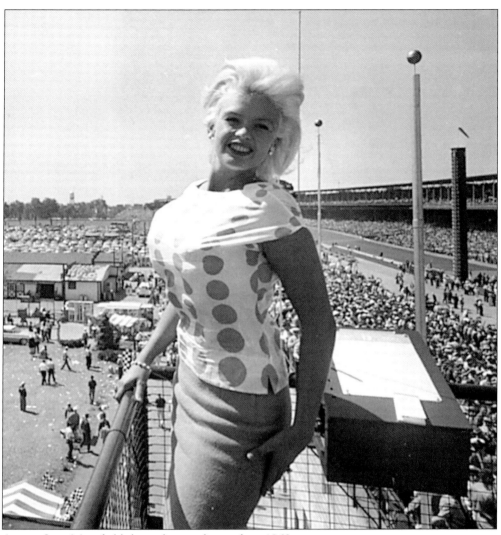

Actress Jane Mansfield showed up at the track in 1962.

Bibliography

Bodenhamer, David J. and Robert G. Barrows, *The Encyclopedia of Indianapolis*, Bloomington & Indianapolis: Indiana University Press, 1994

Fox, Jack C., *The Indianapolis 500*, Cleveland and New York: The World Publishing Company, 1967

"Indianapolis Through Our Eyes," *The Indianapolis Star*, 2003

"Race Car Flashback," Krause Publications, 1994